THE SECOND WORLD WAR IN

1944

JOHN CHRISTOPHER & CAMPBELL McCUTCHEON

AMBERLEY

First published 2015

Amberley Publishing
The Hill, Stroud
Gloucestershire, GL5 4EP

www.amberley-books.com

British Library Cataloguing in Publication Data.
A catalogue record for this book is available from the British Library.

ISBN 978 1 4456 2214 9 (print)
ISBN 978 1 4456 2230 9 (ebook)

Typeset in 11pt on 15pt Sabon.
Typesetting and Origination by Amberley Publishing.
Printed in the UK.

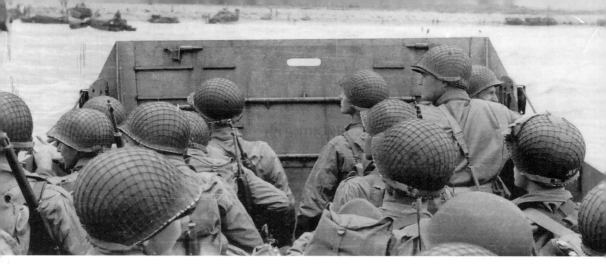

Contents

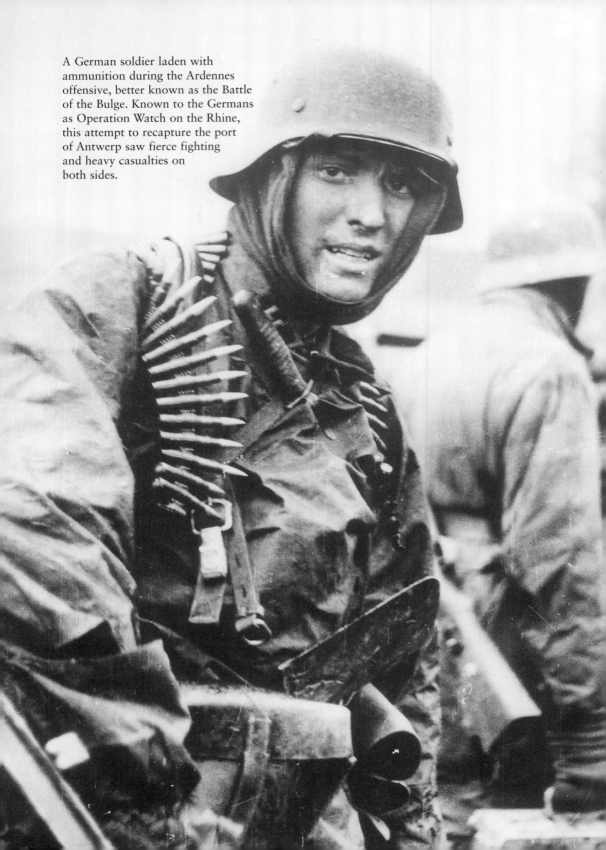

A German soldier laden with ammunition during the Ardennes offensive, better known as the Battle of the Bulge. Known to the Germans as Operation Watch on the Rhine, this attempt to recapture the port of Antwerp saw fierce fighting and heavy casualties on both sides.

LIBERATION & VENGEANCE

1944 was a momentous year. Italy had capitulated and the Germans were on the retreat on all fronts, but still putting up a serious resistance to the Allied onslaught. Japan, too, was on the retreat and the island-hopping techniques of the Americans, Australians and British would see them pushed back closer and closer to their mainland. It was also the year that a generic term for the day a military operation should take place would become the definition of the world's greatest seaborne invasion, an event that would see around 7,000 ships approach the French coast and disgorge some 160,000 troops onto the beaches of Normandy. The year itself would end with a surprise attack by the Germans in the Ardennes that sent the Allies reeling and which terrified the High Command. It was not all successes for the Allies, and September saw the failure of Operation Market Garden and the capture of many British and Polish troops at Arnhem.

After a quiet Christmas period, January saw General Jean de Lattre de Tassigny appointed head of the Free French Forces in North Africa. In the Pacific, American troops land on the north coast of New Guinea. This is part of Operation Dexterity, and is designed to cut Japanese forces off from their supply base at Madang. The capture of Saidor means that 20,000 Japanese troops are trapped between Australian and American soldiers and can only escape through the dense jungle. Twenty-seven Lancasters are lost on a raid over Berlin in the night of 3 January, with 168 crew killed. Damage to Berlin is marginal. With the planning for D-Day well in hand, drops of supplies and weapons to resistance forces in France, the Low Countries and Italy begin in earnest on 4 January, with almost nightly drops, weather permitting, to resistance groups all over occupied Europe. The Russian government has refused to recognise the Polish government in exile and as such the Polish government orders the Polish resistance not to co-operate with the Red Army. An offensive is launched in the Western Ukraine by the Red Army's 2nd Ukrainian Front. On 8 January, the town of Kirovgrad is occupied by the Russians. In Burma, the British XV Corps attacks Maungdaw on 9 January. The 3rd Ukranian Front moves towards Apostolovo on 10 January but stiff German resistance sees them beaten back after six days. Retributions in German-occupied Italy see Count Galeazzo Ciano executed in Verona on the 11th. His crime was to vote to oust Mussolini in July 1943. Having gone to

Bavaria in August 1943, he is handed over to the Italian Fascists. Heavy fighting takes place around Monte Cassino between 12 and 14 January. It is bad news for the Germans on the Eastern Front when the Russians attack towards Novgorod on the 14th in an effort to break the Nazi blockade of the besieged city. A day later, they attack again, this time from the Pulkovo Heights. By 19 January, the three armies attacking the Germans meet, breaking the blockade of Leningrad, in which around 830,000 civilians have died.

The Gustav Line in northern Italy is attacked on 19 January. The British make a seaborne landing at Anzio in order to place forces behind the German lines. The next day, the American II Corps attack and try to cross the Rapido river but are beaten back by tough German opposition, after two armoured divisions are brought into the fray. The Allied VI Corps attacks from the sea on 22 January. Unopposed, 50,000 men and 3,000 vehicles land in a day. The Americans fail to take advantage of the situation and dig in awaiting a counter-attack, rather than force their way inland. By 24 January, the attack is bogging down. In the Pacific, the Australians take Kankiryo Saddle, in Papua New Guinea. The end of the month sees the Americans attack the Marshall Islands, with an invasion of Majuro Atoll on the 30th. As part of the island hopping campaign, the Americans attack key islands, leaving the lesser ones to be starved into submission.

Between 1 and 4 February, the Americans land 40,000 troops on the Marshall islands of Kwajalein, Namur and Roi. The Japanese choose to fight to the death. Over 1,000 Americans are killed or wounded for the loss of over 11,600 Japanese. In Italy, Allied attacks get closer to Monte Cassino on 4 February, meeting stiff resistance for every step gained. The Allied forces at Anzio are contained by German troops and armour in the high ground above the beachhead. 70,000 men, with 18,000 vehicles, are pinned down. In Burma, the Japanese counter-attack, and Operation Ha-Go is meant to stop the British attacks and force them back to the Indian border. By 25 February, the initial Japanese successes have been foiled and they are on the retreat. In northern Burma, Orde Wingate's Chindits attack from India into Burma on 5 February. Their plan is to split the Japanese forces and to draw them away from General Stilwell's forces in the south. A Japanese success on 12 February sees the submarine *I-27* sink the troopship *Khedive Ismail*. Hundreds lose their lives in the sinking but are avenged soon after when the destroyers *Petard* and *Paladin* sink the submarine. Between 16 and 17 February, the US 34th Division fail to take Monte Cassino and are withdrawn and replaced by the 4th Indian and New Zealand divisions. The Germans attack the beachhead at Anzio on 16 February with ten divisions. Despite pushing forward a mile, the Allies throw every aircraft they have in Italy at the Germans and push them back by 19 February. Between 18 and 22 February, the Americans take Eniwetok Atoll and have taken the Marshalls from the Japanese. They lose 254 Marines and 94 soldiers but the Japanese lose 3,400 dead. Porkhov is captured on 26 February and the Russians, in a mere three weeks, have inflicted a humiliating defeat on the German Army Group North. Three divisions are lost, seventeen are in retreat. Around 21,500 Germans are dead, 1,800 guns are

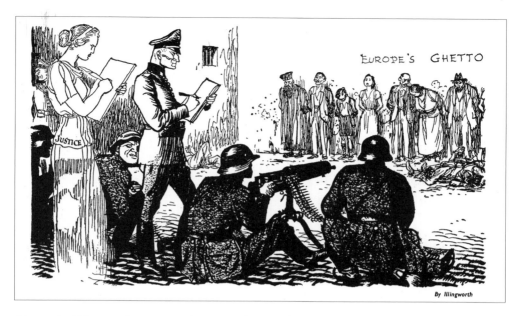

Above: An Illingworth cartoon, 'Europe's Ghetto'. The Warsaw Uprising, from 1 August to 2 October 1944, resulted in the mass execution of between 150,000 and 200,000 Polish citizens.

captured along with 189 tanks, while the Germans are harassed by partisans as they fall back. On this leap year, Rabaul is in the Americans' sights. They are not going directly for the Japanese base but instead attacking the Admiralty Islands, which are on the precarious supply route to Rabaul.

1 March sees the Chindits cross the Chindwin river, with Chinese Nationalists and American forces, namely Merrill's Mauraders under General Stilwell, advancing on Myitkyina. The next day, the Allies cut off aid to the Turks, who have steadfastly refused to help the Allies. In Burma, glider landings by Chindits begin on 5 March. By the 11th, a whole brigade has been flown in. With many of the men at the Front, the Germans begin to recruit women door to door to help in the war factories. With the Allies on the offensive in Burma, the Japanese attack on 7 March, advancing on the road between Tiddim and Imphal, hoping to cut off the 17th Indian Division and to force the British to commit their reserves to rescue the Indian troops. In Germany, the USAAF attacks the Erker ball-bearing works in Berlin with 590 aircraft. They inflict major damage on the works, with seventy-five direct hits, but lose thirty-seven aircraft. On the 11th, in the Ukraine, the 2nd Ukrainian Front reaches the Bug river, where the Germans hope to stop them. Between 11 and 12 March, Buthidaung, Burma, is captured by the Allies, who then go on to take the Japanese fortress at Razabil. Elsewhere in Burma, the Japanese attack across the Chindwin between 15 and 16 March. Cassino, Italy, still holds on, but the Allies capture Peaks 193 and 165 on 15 March. They fail to make any more advances on the 16th, but the next day, they capture the railway station.

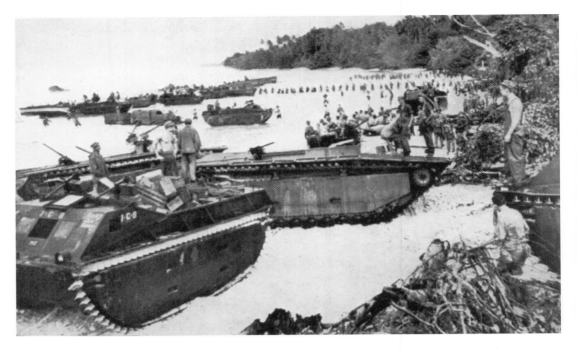

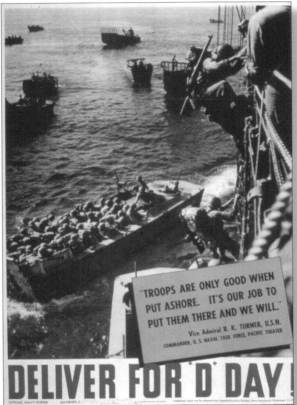

1944 was the year of several major amphibious landings, not only in Europe but also in the Pacific theatre, as shown above. US Marines are coming ashore on Emirau Island, of the St Mathias group, on 20 March 1944.

Left: Deliver for 'D' Day. An official US Navy poster with a message from Vice Admiral R. K. Turner USN, Commander US Naval Task Force, Pacific Theater. While the term D-Day has now become widely associated with the Normandy landings in June 1944, it has its origins in the First World War as a term for the day on which a military operation was to commence. Likewise, H-Hour denotes the exact hour.

On 18 March, Army Group South is split as the Red Army reaches the Dniester river and make a bridgehead at Mogilev Podolsky. The way to the Romanian border is clear. Hitler orders his troops to take Hungary the next day, as the Russians begin their approach to the Balkans. The Regent is forced to allow the Germans to take over the transport system and to help the SS to deport the Jews to concentration camps. The Germans attack from Cassino towards Peak 193 and destroy New Zealand armour assaulting the monastery. Over the next few days, more assaults on Cassino fail and frontal assaults are called off on the 22nd. Major Orde Wingate, the leader of the Chindits, is killed on 24 March, when his aircraft crashes. The end of the month sees the Germans in retreat from the Bug river, and the Red Army's 3rd Ukrainian Front head for Odessa, In Burma, the Japanese have blockaded Indian troops at Imphal by 29 March. Two Field Marshals, von Manstein and von Kleist, are sacked by Hitler on the 30th. Hitler considers they ignored his orders to stand fast. In Burma, on the same day, Chindits are forced to retreat after failing to capture the Japanese supply base at Indaw. On the night of 30–31 March, an RAF raid on Nuremberg sees little damage but ninety-five aircraft are lost.

A thorn in the Allies' side is the *Tirpitz*, the German battleship, which is in Altenfjord, Norway. It is attacked on 3 April by aircraft from the carriers *Victorious* and *Furious* and put out of action for several months. The Japanese have failed to break the Allied defences at Imphal. By 13 April, they are in retreat. On 5 April, Razdelnaya station is captured by the 3rd Ukranian Front. The Germans, split in two, head for Odessa and Tiraspol. The Crimea is beginning to be liberated on 8 April. The Russians, with half a million men, 560 tanks and 1,250 aircraft, face 200,000 Germans and Romanians, with 250 tanks and 150 aircraft. Odessa is reached on 9 April. The Romanians are given a peace proposal on 12 April, which involves them joining the Russians and allowing free access through their country for Soviet forces. They reject the proposal and stay with the Axis forces. In preparation for the attacks on France, the USAAF and RAF shift their priorities from German industrial centres to railway hubs in France and Belgium. On 15 April, an American daylight raid attacks Ploesti and its oilfields, as well as Bucharest, the Romanian capital. That evening, to add to the chaos in Romania, the RAF attacks Turnu Severin. Papua New Guinea is invaded on 22 April by 52,000 soldiers under General MacArthur. Hollandia is taken as part of Operation Cartwheel, which will see the Japanese ousted from north-west New Guinea.

3 May sees the Japanese appoint Admiral Soemu Toyoda as commander of the Japanese Combined Fleet. Sebastopol is liberated on 9 May. The Germans have lost 100,000 troops in the fighting. Between 11 and 18 May, Cassino is attacked again. The 15th Army Group tries to outflank the monastery, while the French take Monte Faito. By the 13th, French, Americans and British are having success, with the road to Rome being taken, as well as the bridgehead over the Rapido river. The Germans evacuate the monastery on 17 May, and its blackened ruins are taken by the Poles on 18 May. In the Pacific, on the same day, the Japanese

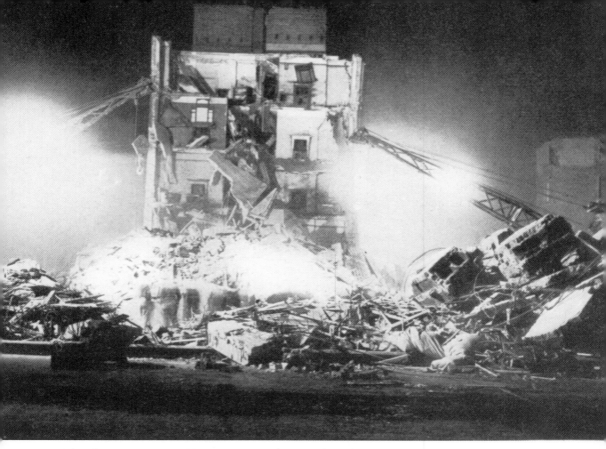

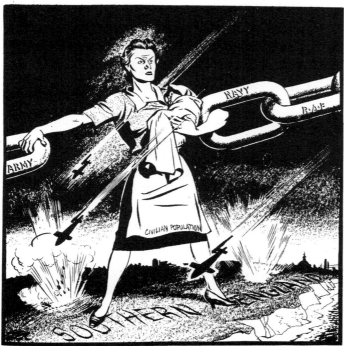

Above: A block of flats in London wrecked by a Luftwaffe bomb. After years of conventional bombing Hitler unleashed his V or Vengeance weapons following the D-Day landings in Normandy.

Left: 'There is no weak link.' A newspaper cartoon published in July 1944 and featuring the V1 flying bombs falling on southern England. These were known as 'buzz bombs' or doodlebugs because of the droning sound of their impulse engines. See page 96 for more on the V1, and page 140 for the V2 rocket.

are evicted from the Admiralty Islands. Rabaul and Kavieng, the main Japanese bases in the south-west Pacific, are now isolated. After the 'great escape' from Stalag Luft III in Silesia, fifty Allied airmen are shot by 19 May by the Gestapo. Only three prisoners get to Britain, two Norwegians and a Dutchman. Despite fierce resistance, Allied troops begin a breakout from Anzio on 23 May. They finally meet up with the US II Corps on 25 May, some four months after they landed at Anzio. The Americans head towards Rome on 25 May, but stiff German resistance is put up on the Caesar Line, near Valmontone. On 30 May, during a surprise night attack, the American 36th Division takes Monte Artemisio and the road to Rome is open again. In Papua New Guinea, on 29 May, a tank battle is fought between the Japanese and Americans at Biak Island. The Americans defeat the Japanese.

Preparations for D-Day occupy the Allies in the West in June. Meanwhile, in Burma, Brigadier Michael Calvert reaches Lakum with the 77th Brigade. On the 3rd, the Japanese withdraw, signaling the end of the Battle of Kohima, after sixty-four days. It is lack of supplies rather than the British and Indian troops that force the Japanese to retire. Hitler gives Kesselring permission to abandon Rome and his troops withdraw over the Tiber as the US Army occupies the city on the 5th. The day after, later than anticipated due to the weather, the Allies land in Normandy in what is the world's largest seaborne invasion. The first soldiers to land are paratroops and glider pilots, who capture major bridges at Caen and secure other objectives. The numbers are staggering and are never likely to be repeated. The initial attack involves 50,000 men, with another 2 million following on. The ships involved include 139 major warships, 221 cruisers and destroyers, 1,300 smaller ships including minesweepers and support vessels, 4,000 landing craft of all sizes, 805 merchant vessels, fifty-nine blockships, as well as 11,000 aircraft. Some 100,000 Resistance are working in France ahead of and during the invasion, harassing the Germans from within.

On beaches like Utah, resistance is weak but at Omaha, the US soldiers are pinned down. The British and Canadian soldiers break out from Juno and Gold, heading towards Caen and Bayeux, and from Sword, they soon meet up with airborne forces dropped overnight. The Germans counter-attack between Sword and Juno beaches but are repulsed. For the loss of 2,500 dead, the Allies have a foothold in northern Europe once more. While the Germans are fighting in the West for the first time since a commando raid on St Nazaire, in northern Russia, the Soviets are trying to force the Finns back to their pre-1939 border. The guns start firing on 9 June and the next day the Finns withdraw to a defensive line. One of the worst atrocities in the West takes place on 10 June as the Germans destroy the village of Oradour-sur-Glane. Of the 652 people in the village only ten survive the massacre and the village remains to this day as a monument to the dead, murdered by men of the 2nd SS Panzer Division 'Das Reich'. In the Pacific, on 11 June, the islands of Saipan, Tinian, Guam, Rota and Pagan are bombed and shelled in preparation for seaborne landings. A tank battle at Villers-Bocage, in Normandy, on 13 June, sees some twenty-seven British tanks destroyed. The

Japanese plan Operation A-Go, a trap to lure the American fleet to the Palaus or Western Carolines, where the plan is that they will be destroyed by superior Japanese firepower and aircraft from the numerous island bases in the vicinity. American forces land at Saipan on 15 June and the Japanese Combined Fleet is sent to the islands, scuppering the plans to destroy the Americans elsewhere. Flying from bases in China, B-29s bomb Yahata, and its vital steelworks. The 16th sees Stilwell's Chinese forces attack and capture Kamaing from the Japanese. The bottom of the Cotentin Peninsula is captured on 18 June and the German troops in Cherbourg and the Channel Islands are cut off from the rest of the Axis forces. The garrison is ordered to fight to the death by Hitler. The Japanese fleet have set sail for Saipan, having heard of the American invasion. The American fleet is spotted at daybreak on 19 June and Japanese planes are soon heading towards them. The Japanese carriers *Taiho* and *Shokaku* are sunk by US submarines and many of the aircraft are shot down by the numerically superior American planes. The Japanese lose 346 aircraft for the loss of thirty American ones. Two vital carriers are lost for some damage to an American battleship. Another Japanese carrier is lost on 20 June, along with two oil tankers. Sixty-five Japanese aircraft are lost for twenty American planes. The Marianas 'turkey shoot' decimates the Japanese air force with the loss of 460 trained pilots.

In Umbria, Italy, the British XXX Corps attacks the Albert Line. This is a rearguard position for the Germans and they fight determinedly on, giving little ground, despite the onslaught. Imphal is relieved on 22 June, but Japanese soldiers still offer stubborn resistance. Mogaung, Burma, is attacked on 22 June and the Japanese abandon the area on 26 June. The Belorussian offensive begins as the Red Army attacks Army Group Centre on 23 June. The Germans are being attacked on all fronts and Operation Epsom, which begins on 26 June, sees the British set their sights to the west of Caen. Resistance is stiff and the assault is halted after the British suffer many losses. Cherbourg surrenders on 29 June, and despite an order to fight to the death, 39,000 German troops surrender. The Americans have lost 22,000 dead and wounded. The Luftwaffe introduces its wonder weapon, the Messerschmitt Me 262 jet fighter, and the first operational jet fighter squadron will soon be in action in France. By the end of the month, around 2,000 V1 doodlebug bombs have been launched against targets in London and the south-east of England. Powered by pulse jets, the V1 is one of Hitler's secret weapons that also include the V2 rocket and the Me 262.

The German Albert Line is broken through on 2 July, when the British occupy Foiano. The Red Army begins its move to occupy the Baltic states of Latvia, Lithuania and Estonia on 4 July. In the Pacific, the Japanese commander on Saipan orders his troops to make a suicide charge at the Americans on the 7th. Hundreds die but the Japanese break through the lines of the 27th Infantry Division where many are killed. The commander commits suicide, as do around 8,000 defenders, who would rather die than be under the American yoke. The Russians are banging on the doors of Hungary and the Hungarians halt the deportation of Jews to concentration camps, including Auschwitz, on 8 July.

The Red Army takes Minsk on the 11th, with the victory seeing the loss of over 70,000 Germans killed and 35,000 injured. The Russians are less fortunate on the Karelian Isthmus as they fight the Finns. The battle for the Isthmus ends on the 15th with the Russians on the defensive. The Red Army reaches Poland, crossing the Bug river on 17 July. In Normandy, fighting is intense. The Americans reach St-Lô on 18 July. Southern Caen is taken on the 22nd for the loss of over 100 Sherman tanks, but they succeed in wearing down the German armour too.

Guam sees bombardment by American navy vessels on 19 July as they prepare for the invasion of Asan and Agat. The invasion begins on 21 July and the US troops meet stiff resistance. An attempt is made to assassinate Hitler on 20 July. A bomb is planted in the room Hitler is holding a meeting in at his Rastenburg headquarters. It explodes at 12.42 after the man who has left it, Count von Stauffenberg, leaves. Hitler is injured and the bomb plot fails. Over the next few months, dozens of conspirators are killed by the Nazis. The most notable of those who die is Field Marshal Erwin Rommel. In Italy, Livorno is occupied on 19 July and Pisa is conquered on the 23rd. Two days later, Operation Cobra begins. The breakout from Normandy starts with huge air raids and three divisions of the American VII Corps attack between Marigny and St Gilles, opening a breach there. The tanks are on the move at last. Avranches is reached in less than a week. The Japanese attack the Americans in the Marianas on 25 July. The counter-attack to try and throw the Americans back into the sea is thwarted. The Americans see 1,744 casualties against 19,500 Japanese dead. Tinian Island is invaded by the US 4th Marine Division. Lvov is liberated by the Soviet 1st Ukranian Front on 27 July. The Red Army, after taking Lvov, bridges the Vistula river in numerous places on 30 July. Avranches falls the same day.

August opens with the Warsaw Uprising. Around 38,000 Poles fight a similar number of Germans. The Germans have more and better weapons and they have tanks. The Poles attack in an effort to give the London-based Polish government in exile some hope of power after Poland is liberated. With the Red Army close to Warsaw, it is hoped the city will be relieved soon. In the Pacific, Tinian Island is captured on the 1st but the Japanese defenders have indeed fought to the death, with all 9,000 killed. It is a sign of what is coming as the Allies get closer and closer to Japan itself. On 2 August, the Red Army crosses the Vistula south of Warsaw. Following eleven weeks of siege, the Japanese withdraw from the Burmese town of Myitkyina on 3 August. The Nazis hang eight German army officers as a result of the bomb attack on Hitler. The event is filmed for Hitler and the men, including Field Marshal Erwin von Witzleben, are hanged using piano wire. Guam surrenders on 10 August. Some Japanese soldiers in the jungle refuse to surrender and the last finally gives up in 1960, fifteen years after the war ends. The attack on Falaise, Normandy, by the Canadians is called off on 11 August, with a failure to capture the town. As the Russians take control of large parts of Poland, the Russian government informs its Allies that the Polish government in exile will not take part in the discussions about the fate of Poland post-war. Only the Soviet controlled Polish Committee of National Liberation is to be involved. Southern

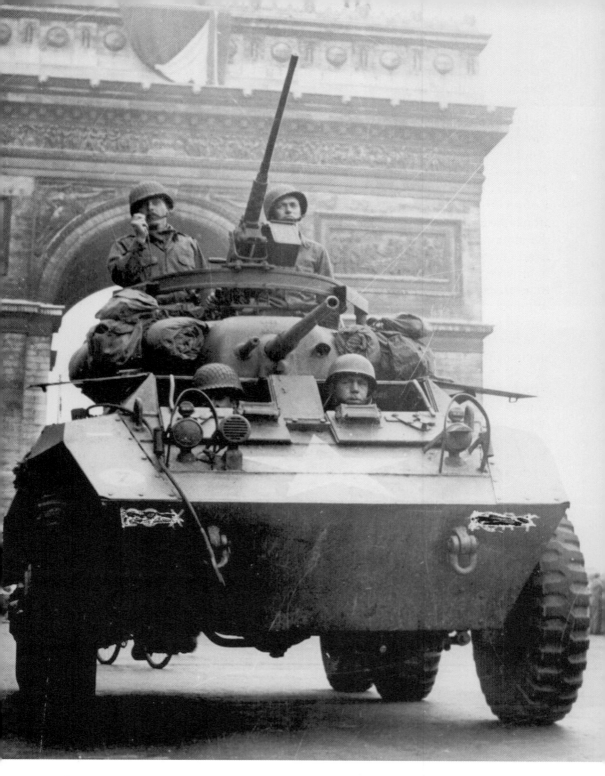

Above: An American armoured car in Paris following the city's liberation on 25 August 1944.

France is invaded on 15 August by the Americans and French, opening a second front in France. The Falaise Gap is closed on 19 August after a fortnight of hard fighting as the Canadians try to cut off the 90,000 German soldiers in the town. Some 30,000 escape, with 10,000 dead. On 23 August, the Romanians capitulate and surrender. Grenoble is captured on the same day, while Eisenhower rejects Montgomery's pleas for a thrust into northern Germany. Romania declares war on Germany on 25 August and Paris is surrendered pretty much intact to the Allies. There has been some fighting and around 500 resistance fighters are killed, along with 127 civilians. The British cross the Seine while in Italy, the Allies attack the 200-mile long Gothic Line. They meet fierce resistance. On 27 August, the remaining Chindits in Burma are taken back to India. While the Russians have a grandstand view of the German air attacks on Warsaw, the Polish Home Army have taken to the sewers in their fight for independence post-war. As the Russians approach Slovakia, the partisans revolt on 30 August. The last day of the month sees British forces capture every important bridge over the River Somme at Amiens and an attack by the Americans towards the Meuse.

Between 1 and 3 September the Canadians arrive in Dieppe for the first time since their failed attack in 1942. Arras and Aubigny are reached by the British. The XXX Division is halted on the 2nd, awaiting a proposed parachute drop, which is subsequently cancelled and the attack begins again. 32nd Brigade reaches Brussels on 3 September, while the advance of the XII Corps is slowed in the fight for Béthune. The Finns and Soviets reach an armistice deal on 2 September, while Red Army troops reach the borders of Bulgaria on the same day. A full five years after Britain became involved in the war, Brussels is liberated, while Tournai is taken by the Americans. Antwerp is liberated on 4 September, giving the British a vital port closer to the fighting. In Italy, the British Eighth Army, which fought against Rommel's Afrika Korps, is stuck at the Gemmano–Coriano Ridge, on the Gothic Line. In one attack the British lose half their tanks against the heavily-defended German positions. The advance continues and the American Third Army crosses the Meuse on 5 September. The Russians declare war on Bulgaria, invading the country. Realising the end of the war is going to see a change in the geo-political mix in Europe, their intention is to take control of all of Eastern Europe. Turnu Severin is reached on the 5th. After three days of invasion, Bulgaria's leadership declares war on Russia. B-29 bombers take off from Chinese mainland airfields for attacks on Japanese industrial targets.

On the 8th, the British 50th Division takes its troops and tanks across the Albert Canal. Two days later, a British armoured division reaches De Groot. The Meuse–Escaut Canal is crossed on 13 September. The Dukla Pass, the most important one through the Carpathian Mountains, in Slovakia, is attacked by the Soviet 1st and 4th Ukrainian Fronts on 8 September. Fighting is hard in the mountains and it will take two months to fully clear the Carpathians. In Poland, units of the Red Army attack Praga, part of the city of Warsaw, despite Stalin's orders that the Home Army will not be helped. By 14 September, Praga is conquered on the 14th. With the Poles almost defeated, the Russians move in to

attack the Germans in Warsaw. The Vistula is crossed on the 15th. The *Tirpitz*, still a thorn in the British Royal Navy's side, is attacked by Lancaster bombers, but the aircraft inflict little damage. One of the largest airborne drops of the war starts on 17 September. Operation Market Garden is designed to capture bridges over the Rhine that are essential for the speedy conquest of the Netherlands and to open the route to Germany. The British land near Arnhem, along with Polish soldiers, while the Americans land at Grave and Nijmegen. Faulty intelligence meant that at Arnhem the British landed close to a German armoured battalion. Fighting is hard but troops reach the bridge at Nijmegen and the Maas–Waal Canal bridges. In Yugoslavia, Marshal Tito allows the Russians passage through the country, after meeting Stalin. Rimini is captured on 21 September. To achieve this, the British have lost 10,000 men and 200 tanks. Fighting still takes place in France and Boulogne is taken on 22 September. Its 20,000 German occupiers are marched into captivity.

At Arnhem, a drop by paratroops of the Polish Brigade is made on 22 September but they and the British XXX Corps are beaten back. By the 25th, Arnhem is evacuated, leaving 2,500 dead behind. The Dortmund–Ems Canal is bombed on 23 September, using Lancasters and giant earthquake bombs. The canal is breached in numerous places but the RAF loses 10 per cent of its 141 bombers. Calais is attacked on 23 September by the Canadian 3rd Division. After a week of house to house fighting, the garrison of 7,500 surrenders at the end of the month.

The last Poles surrender in Warsaw on 2 October and the Germans set about destroying what remains of the city. They have killed 150,000 Poles for a loss of 26,000 German soldiers and airmen. Attacks by V2 rockets continue from mobile launch sites in the Netherlands and the city of London is under constant threat from these supersonic missiles. British forces land in Greece on 4 September, in an attempt to prevent Greek communists taking power as the war winds down and German forces withdraw. Despite Antwerp having been taken in early September, the Allies cannot use the port due to German troops on either side of the River Scheldt, which winds its way down to Antwerp. The Canadian forces are used to clear the banks of the river from 9 October. It is decided that Iwo Jima, in range of the Japanese mainland, will be the next island in the Pacific to be attacked by the Allies. Greece is abandoned by the Germans, who need the troops elsewhere. They have a limited success in Debrecen, Hungary, from 10 October, when a huge tank battle initially goes in their favour. The war in the Balkans has turned in the Allies' favour, and the Red Army has joined forces with the Yugoslavians as they head for Belgrade, which the Germans abandon on 19 October. Field Marshal Rommel commits suicide on 14 October. General MacArthur steps ashore at Leyte, Philippines, on 20 October, keeping his promise made as he fled the islands in 1942 that he would return. Belgrade is captured the same day. After ten days of siege, Aachen surrenders to the US Army on 21 October.

The Battle of Leyte Gulf sees the Japanese try to stop the American invasion of the Philippines. It is the end of the Japanese navy as an effective fighting force and

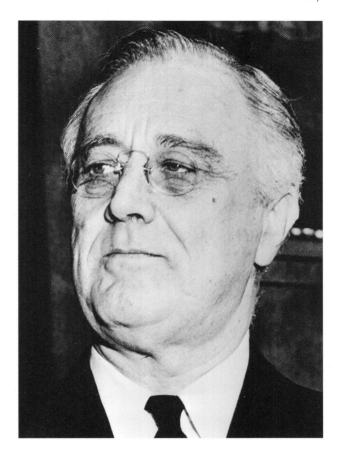

Right: On 7 November 1944, Franklin Delano Roosevelt won the US presidential election for a record fourth time. He had already served for longer than any previous president and despite declining health he remained popular with the voters.

casualties, especially among trained naval pilots, are high. 500 pilots are dead, four aircraft carriers are sunk, along with three battleships, six heavy and four light cruisers. Eleven submarines are also lost, for the loss of 200 US aircraft, one light carrier, two escort carriers, a destroyer escort and two destroyers. In the Baltic, the remnants of Army Group North, which had triumphantly marched into Russia in 1941, are contained in the Courland Peninsula by 31 October.

The Scheldt estuary has been purged of German soldiers by 8 November, with the Canadian soldiers taking 41,000 prisoners for the loss of 12,873 men. The previous day, Richard Sorge, a spy who was sending secrets to the Russians, including information on Operation Barbarossa, the invasion of Russia, is hanged by the Japanese. Patton's Third Army crosses the Moselle river on 9 November. In preparation for invasion, Iwo Jima is bombed for the first time on 11 November and on the 12th the *Tirpitz* is finally sunk in Norway, with the loss of 1,100 crew. Tokyo is bombed by Boeing B-29 Superfortresses on 24 November.

After months of fighting in Burma, the Japanese are on the retreat and British forces begin the job of evicting them from the country. The airfields at Yeu and Shwebo are attacked on 4 December. The Japanese are also under intense

pressure in the Philippines with the US forces attacking on Leyte. In Germany, women are urged to take over jobs to release men for the Front. Bombardment of Iwo Jima begins on 8 December. Softening the island up before invasion will take a full seventy-two days. On 15 December, the Philippine island of Mindoro is invaded by the US 24th Division, while, in Burma, the two British forces, the 19th and 36th Divisions, join together at Indaw, creating a united northern front against the Japanese in Burma.

In terrible winter weather, Hitler launches his planned fight back – Operation Watch on the Rhine – with his soldiers intending to cross the Meuse and recapture Antwerp. 200,000 German soldiers, including two Panzer Armies, face 88,000 American GIs. There is total surprise and the fog and low cloud mean that the Allies cannot use their aircraft. At Malmedy, some seventy-one American soldiers are murdered by the SS. The Americans abandon St Vith on 22 December, having seen 8,000 casualties out of the 22,000 defenders. Bastogne holds out, while the Germans try desperately to reach the Meuse. Using English-speaking soldiers, the Germans try to spread confusion behind Allied lines. Many of these soldiers, using captured jeeps and uniforms, are caught and executed as spies. In the Mediterranean, in Greece, communist rebels have been besieging the British base at Kifissia. These ELAS rebels are finally routed on 20 December. The Germans have been developing jet bombers and the very first jet bomber mission takes place in Belgium, when Arado 234B bombers attack railway marshaling yards and a factory. Fighting continues in the Ardennes over Christmas. The surprise German attack has created a bulge in the Allied front lines and the Battle of the Bulge, as the campaign becomes known, sees the Americans counter-attack on Boxing Day. The First and Third Armies attack both north and south of the bulge, squeezing the Germans within. Bastogne is relieved and the plan to take Antwerp has failed miserably. By committing his forces in the battle, Hitler has used up much of his strategic reserves. The Germans will no longer be as effective a fighting force. The end of the month sees General Patton attack to the north-east of Houffalize on the 30th. The Germans simultaneously try and take Bastogne but are defeated. The Soviets have taken control of much of Hungary and the last day of the month sees the provisional National Government of Hungary, a Soviet puppet government, declare war on Germany.

The war is about to enter its final year and the final months of 1944 have seen the war reach home soil for both Japan and Germany. Their allies have turned against them and the end is imminent. Both have committed their best men and equipment and cannot replace either man or machine in sufficient quantities to match the numbers of men and quantity of equipment being rolled out of British, American, Canadian and Australian war factories. There will be much mopping up to do as pockets of resistance have been bypassed as they offer no strategic benefit in their capture but it is obvious the war can only end in one way.

1945 will end the story of the Second World War and the war will end in a way that few could imagine, one so big that it will have repercussions that will reverberate for the next seven decades.

JANUARY 1944

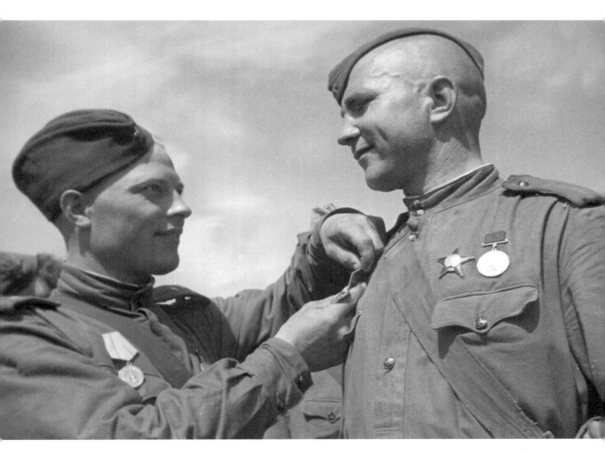

Above: A Soviet soldier being awarded the Defence of Leningrad Medal. The campaign medal, awarded to both civilians and the armed forces, recognised the valour and hard work displayed during the 872-day siege of the city, which finally came to an end on 27 January 1944. It was one of the longest sieges in history and resulted in extensive casualties and damage to the city. *(Novosti)*

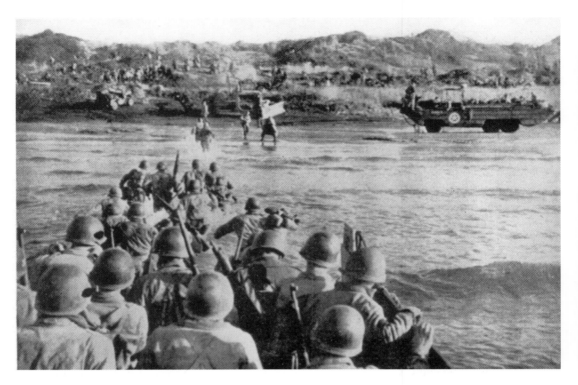

Anzio Landings in Italy

Operation Shingle was the name for the Allied seaborne landings at Anzio, on the western coast of mainland Italy, on 22 January 1944. The Allies had already landed in southern Italy in September of the previous year but had become bogged down at the Gustav defensive line to the south of Rome. Shingle was intended to bypass the German defenders to thrust straight towards the capital, Rome. *Above:* US troops pour on to the beach near Nettuno under the protection of naval and air cover. *Below:* Amphibious six-wheeled DUKWs, or 'Ducks', reach the shore.

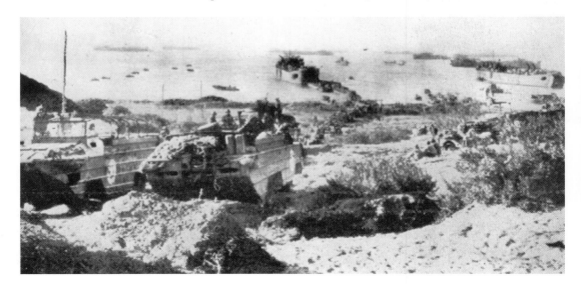

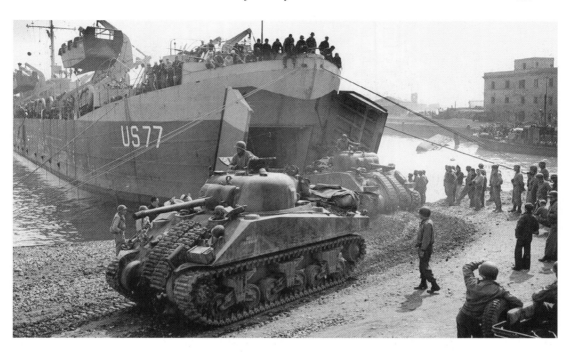

Above: Once the beachhead had been consolidated at Anzio it became a key landing point for Allied equipment and supplies arriving in Italy. Sherman tanks are shown being brought ashore at the harbour. *Below:* These M7 105-mm Howitzer Motor Carriages are moving up from Anzio. They are manned by gunners of a British field regiment.

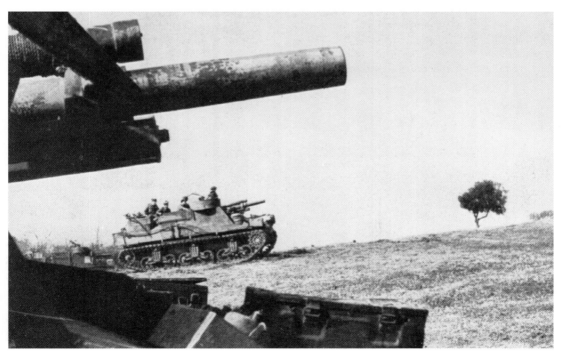

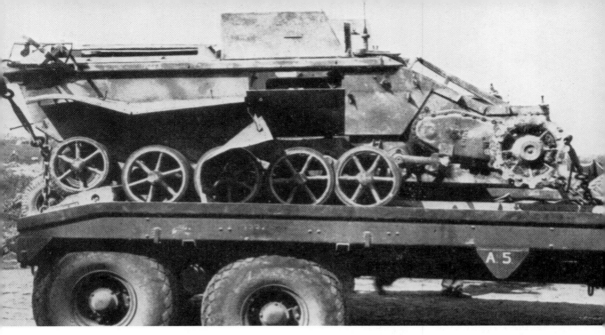

Robot Wars

As Germany's plight became ever more desperate in the latter stages of the war, a range of secret weapons developed by Hitler's engineers were thrown at the enemy in an attempt to stave off the inevitable. In addition to the airborne robot bombs, these included the radio-controlled demolition tanks shown here.

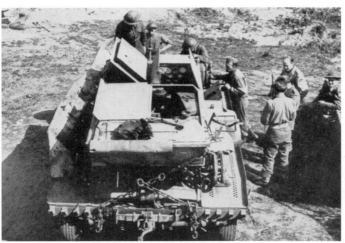

Above and middle left: This 12-foot-long unmanned demolition vehicle is the Borgward IV captured by the Allies at Anzio. It is radio-controlled and was able to drop its explosive charges and leave the area before detonation.

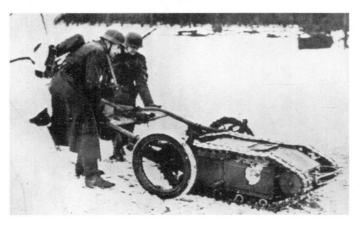

Bottom left: The much smaller Goliath was also known as the 'beetle tank' by the Allies. With two electric motors, it could carry a 130-lb explosive charge and was controlled via a 2,130-foot cable. This example is shown prior to deployment in Russia.

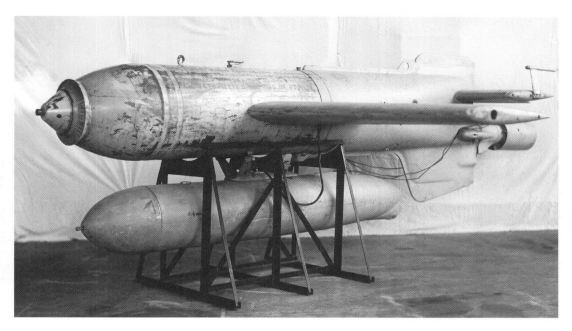

On 23 January 1944, HMS *Janus* and HMS *Jervis* were both struck by German glide bombs, most likely the Henschel Hs 293, shown above, off Anzio during Operation Shingle. In effect a guided missile, the Hs 293 was air-launched from a carrier aircraft, usually a Dornier Do 217 or Heinkel He 111. This meant it could be released out of range of a ship's defences and was then guided to its target by radio, its HWK 109-507 rocket engine providing ten seconds of thrust. With a 650-lb warhead the Hs 293 was intended for attacks on unarmoured ships, but in the Anzio attack *Janus* sank and *Jervis* was badly damaged. *Below:* He 111 with Hs 293 missile.

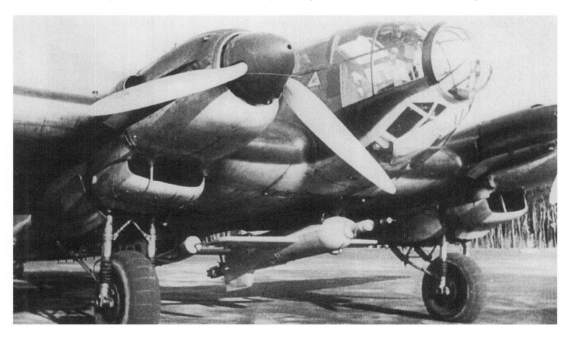

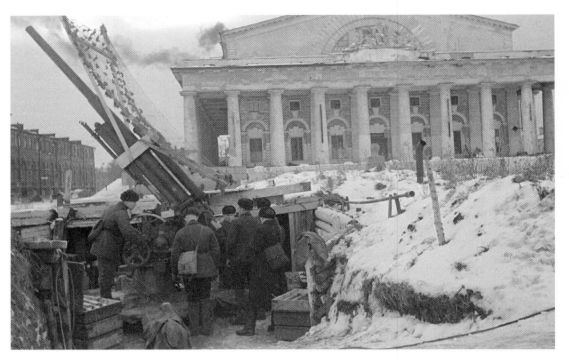

The Eastern Front

Also known as the Leningrad Blockade, the German siege of the city had begun on 8 September 1941 and dragged on for 872 days, only to be lifted on 27 January 1944. *Above:* Russian anti-aircraft gunners ready for battle in a city square. *Below:* Map showing the battle-line on the Russian southern front and the Kiev bulge, at 11 January 1944

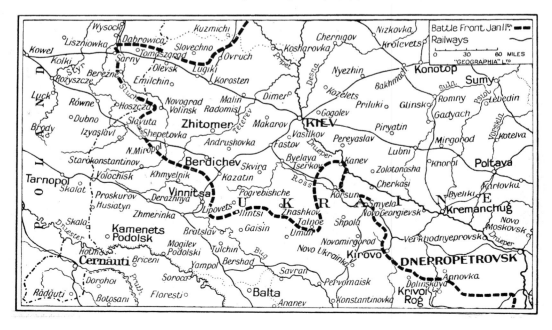

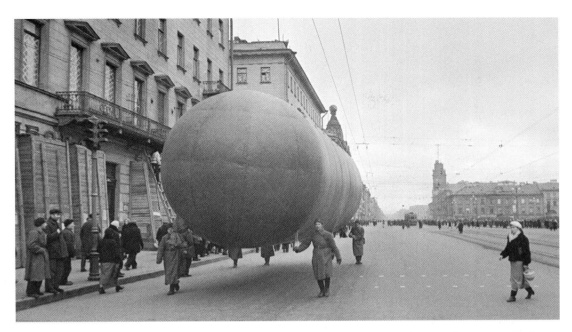

Two more photographs from the Siege of Leningrad. *Above:* A gas-filled balloon is walked along Nevsky Prospekt. It is most likely that this tail-less balloon is being used as a container to transport gas for the barrage balloons used to defend the city. *Below:* A Leningrad street scene showing the result of the German bombardment. The citizens also suffered from extreme starvation during the seige and around 700–1,000 died every day, mostly from hunger.

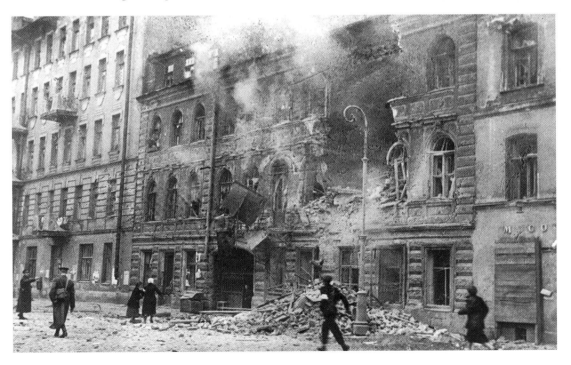

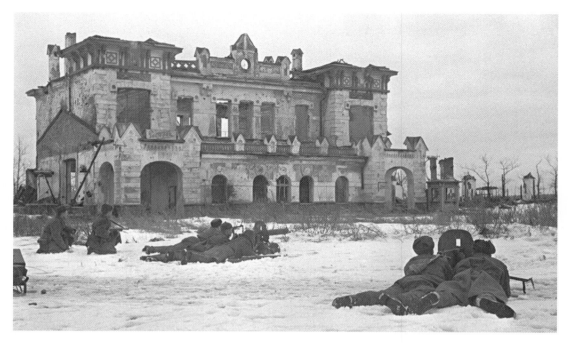

Above: Fighting on the outskirts of Leningrad. Soviet machine-gunners are shown near the railway station in the town of Pushkin, a few miles to the south of Leningrad. *Below:* The 'defenders of Leningrad', sailors together with a group of workers from the Kirov plant, which produced the T-34 tank during the war, celebrate the lifting of the seige. *(Novosti)*

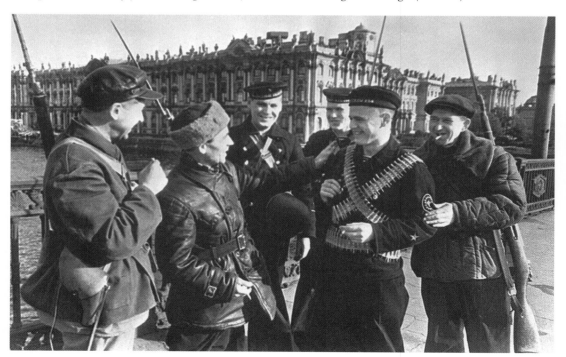

Right: A map showing the
Leningrad area where the Soviets
launched their winter offensive
following the ending of the
prolonged siege of the city. The
black line indicates the battle line
on 25 January 1944. (Since 1991
Leningrad has reverted back to
its pre-revolutionary name of
St Petersburg.)

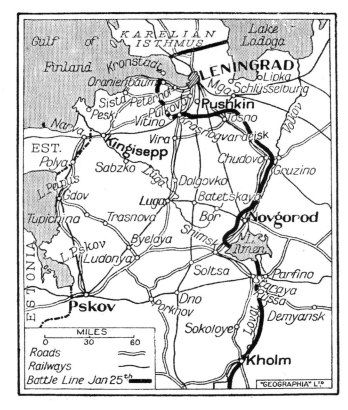

Below: German infantrymen fire
at the Red Army forces from the
protection of a slit trench.

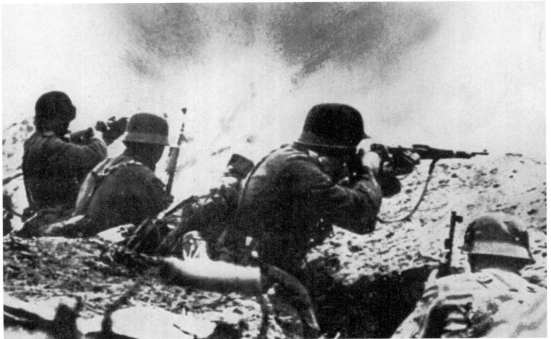

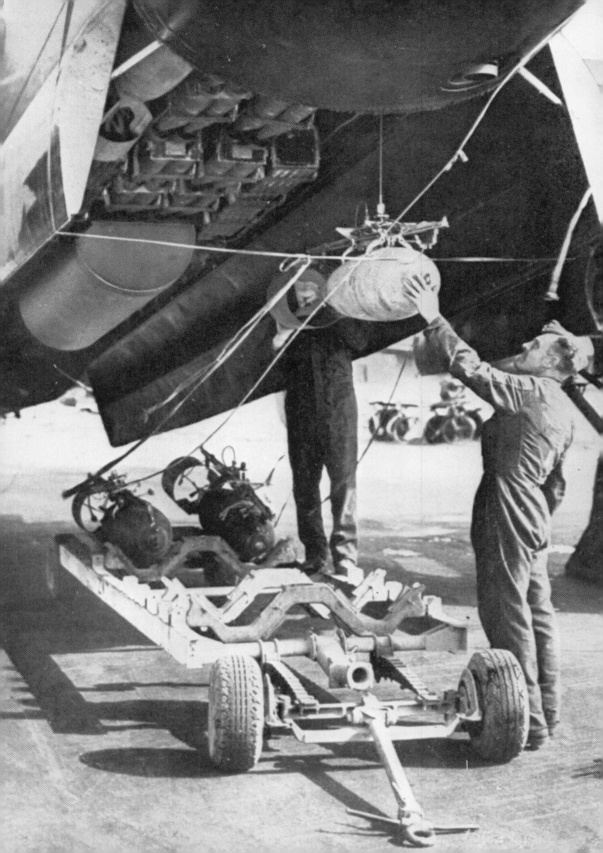

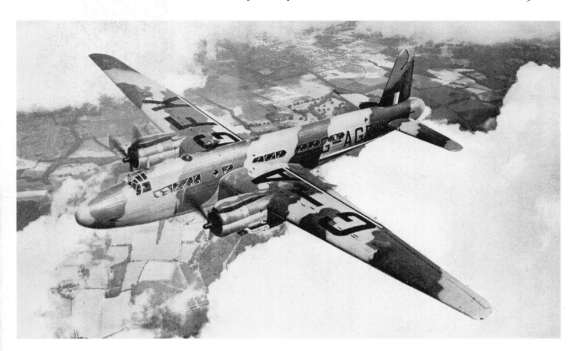

War in the Air

The strategic bombing offensive against Germany continued into 1944, but the Allies saw heavy losses. On the night of 3 January a 1,000-bomber raid resulted in the loss of twenty-seven RAF Lancaster bombers. *Opposite page:* Loading 500-lb high explosive bombs within the belly of a Lancaster. Introduced into service in February 1942, the 'Lanc' went on to become the most famous and successful of the night bombers of the Second World War. 7,377 were built.

Other aircraft in service with the RAF included the Vickers Warwick transport, shown above, and the American-built Martin 187 Baltimore, shown right attacking the railway station at Sulmona in Italy. Produced in large numbers, the Baltimore was a twin-engined light attack bomber.

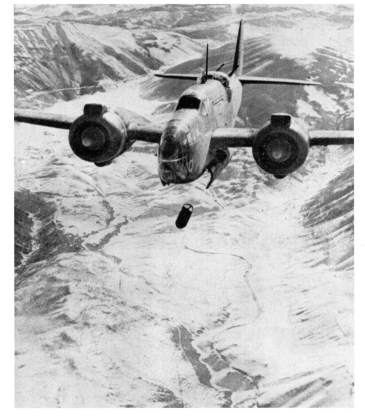

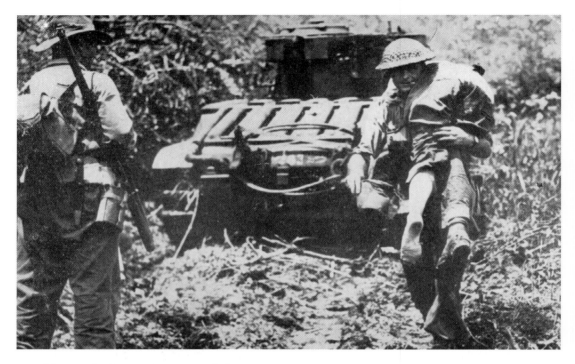

The War in the Far East – New Guinea

Above: When the Australians made a dawn assault on Sattelberg, New Guinea, they moved in behind Matilda tanks. A soldier is shown carrying a wounded comrade. *Below:* Landing a Jeep during the New Britain campaign. The US Marines had stormed ashore on 26 December 1943 and the fighting to take this island, to the east of New Guinea, continued until August 1945.

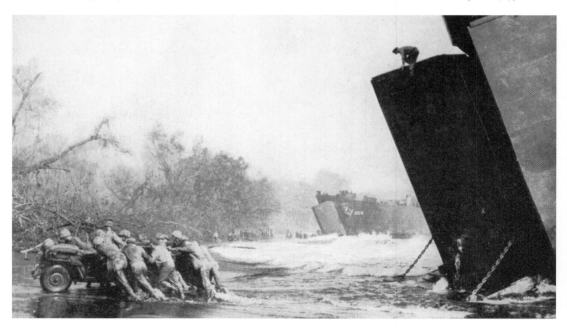

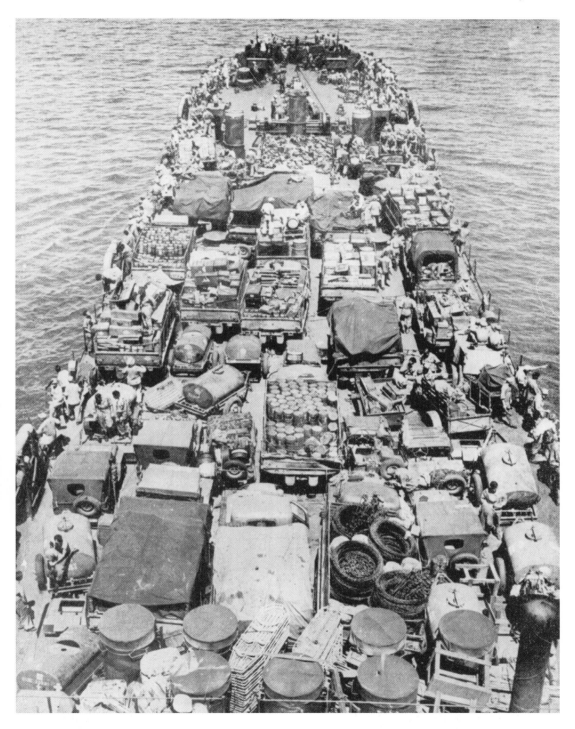

Above: An Allied supply ship, fully loaded with vehicles, food and other supplies, nearing Cape Gloucester on the crescent-shaped island of New Britain in early 1944.

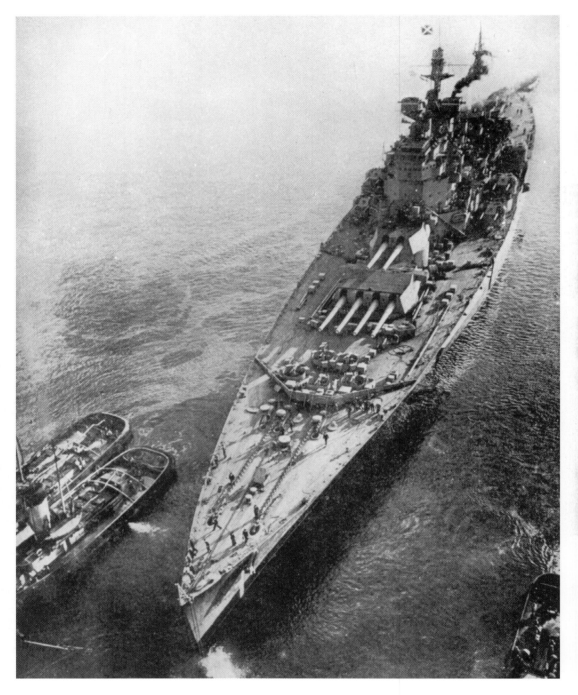

Above: The Royal Navy's 35,000-ton battleship HMS *Duke of York*, which had encountered and sunk the *Scharnhorst* on 26 December 1943. This action, in which the *Duke of York* was also hit, took place during the Battle of the North Cape – part of the Arctic Campaign – and was the last battle between the big gun capital ships of the two navies in the Second World War.

FEBRUARY 1944

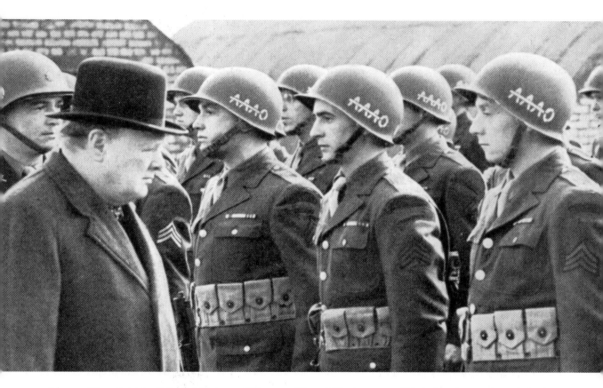

Above: The British Prime Minister, Winston Churchill, inspects US infantrymen based in England as the Allies prepare for the forthcoming D-Day landings and their return to mainland Europe. Their helmets are inscribed with AAAO, with a bar passing through the first three letters, signifying 'Anywhere, Anytime, Anyhow, Bar Nothing'.

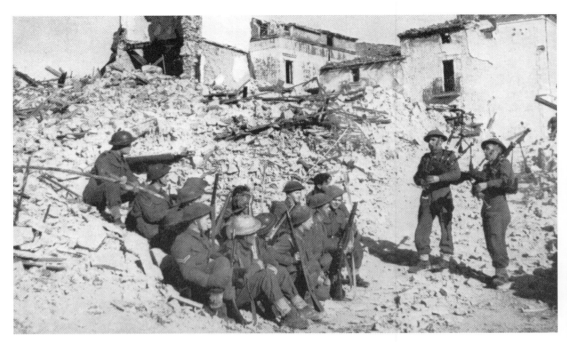

By early 1944 the action had spread to all areas of the conflict. *Above:* Two images from the Allied advance in Italy. Soldiers of a Scottish regiment produce improvised entertainment amid the ruins of a town on the road to Cassino. Shown bottom, Polish soldiers fighting with the Eighth Army come to grips with the local transport.

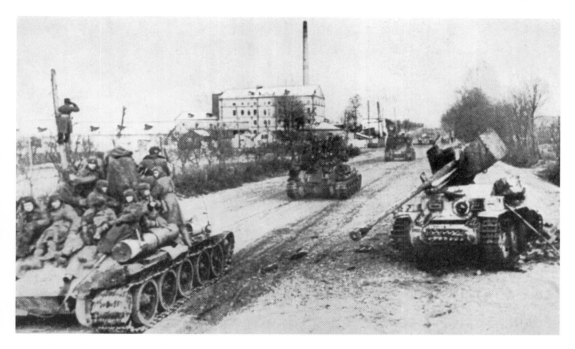

Above: Tank-borne soldiers of the Red Army are shown moving up to the fighting area on the Ukrainian front where the Germans were being pushed back to the River Dniester. *Below:* Lord Louis Mountbatten, the Supreme Allied Commander South East Asia Command, inspects a detachment of Indian troops who would be involved in the battle in Arakan in early February.

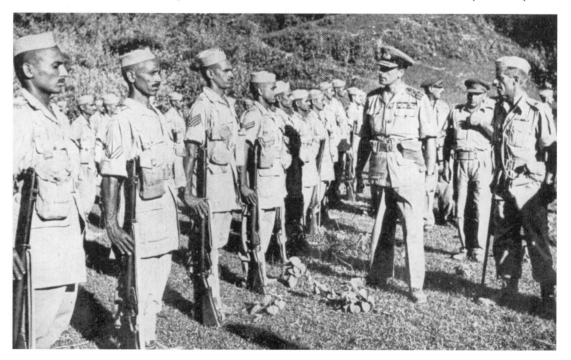

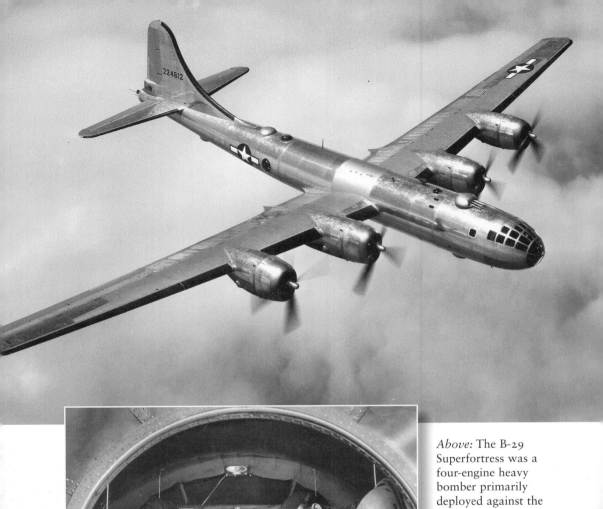

Above: The B-29 Superfortress was a four-engine heavy bomber primarily deployed against the Japanese during the Second World War. It became operational in 1944 and went on to serve in Korea.

Left: The B-29 boasted some advanced design features including a pressurised cabin, and remote-controlled gun turrets. This photograph shows the pressured rear cabin equipped with bunks for the crew to rest on long missions.

The B-29 Superfortress

Boeing's B-29 heavy bomber was introduced into service on 8 May 1944, and during the Second World War it was used exclusively in the Pacific theatre. A very advanced aircraft for its time, it had a pressurised cabin, electronic fire-control systems, and four remotely-controlled machine-gun turrets. The B-29 was one of the biggest aircraft of the war with a wingspan of just over 141 feet and a fuselage length of 99 feet. It was powered by four Wright R-3350 Duplex cyclone turbo-supercharged radial engines, each with 2,200 hp. Maximum speed was 357 mph with a cruise speed of 220 mph that gave an impressive range of 3,250 miles. The eleven-man crew consisted of the pilot, co-pilot, bombadier, flight engineer, navigator, radio operator, radar observer, right and left gunners, central fire control and a tail gunner. With its pressurised cabin the B-29 was capable of flying at an altitude of up to 31,850 feet, although its performance as a high-altitude bomber proved disappointing and instead it became the primary aircraft in the firebombing campaign against Japanese cities. One of its final roles was to drop the atomic bombs on Hiroshima and Nagasaki in August 1945.

The B-29 also served in Korea, with the final mission flown in July 1953, but looking outmoded in comparison with the newer jets, it was retired in 1960.

Below: A ceremony held at Boeing's Wichita plant in February 1945 to mark the delivery of the 1,000th B-29. By the time produced ceased in 1946, 3,970 B-29s had been built. *(NARA)*

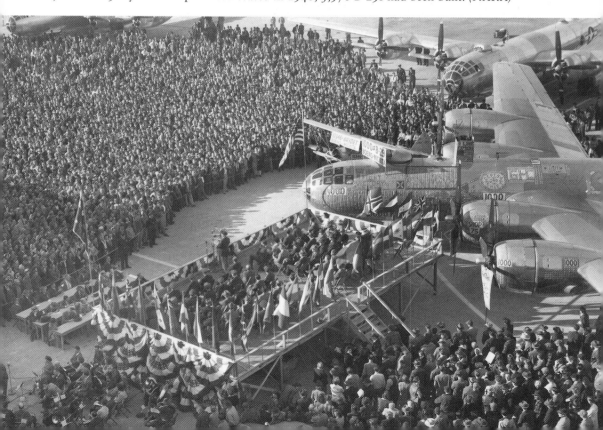

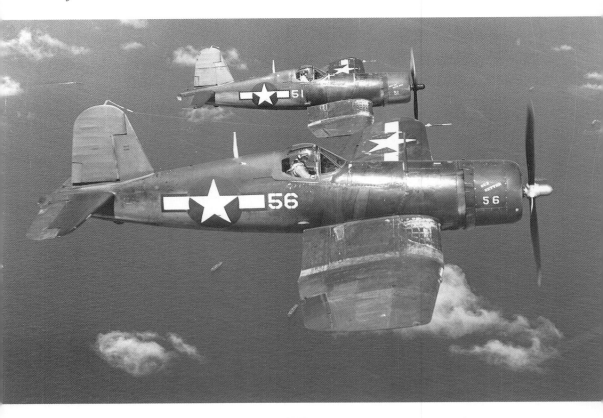

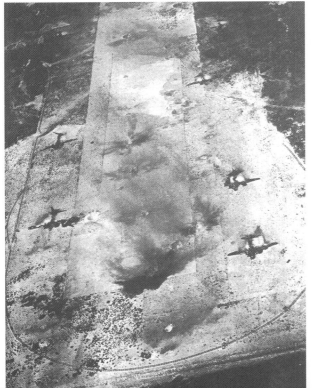

The Marshall Islands Campaign
The purpose of capturing the Gilbert and Marshall Islands, on the outer perimeter of eastern defences for the Japanese, was to establish airfields for the upcoming operations across the Central Pacific. Commenced in November of the previous year, it reached its conclusion in February 1944 following amphibious landings by US Marines on the three main islands of the Kwajalein Atoll.

Top: Two US Marine Corps Vought F4U-1A Corsairs flying near Eniwetok. The F4U-1A was a carrier-based fighter aircraft powered by a Pratt & Whitney R-2800-8 radial engine, producing 2,000 hp and a max speed of 417 mph.

Left: Burning Japanese aircraft after an attack on an airfield on the Eniwetok Atoll. *(NARA)*

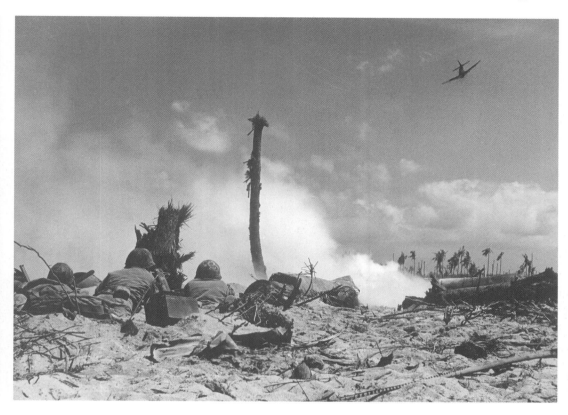

Above: A scene from the Battle for Eniwetok Atoll, fought between 17 and 13 February 1944. A US aircraft is shown strafing the enemy hidden in their trenches, while in the foreground Marines pepper the Japanese positions with gunfire.

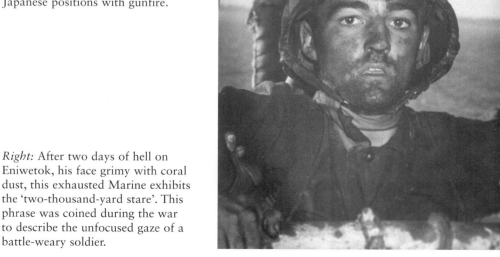

Right: After two days of hell on Eniwetok, his face grimy with coral dust, this exhausted Marine exhibits the 'two-thousand-yard stare'. This phrase was coined during the war to describe the unfocused gaze of a battle-weary soldier.

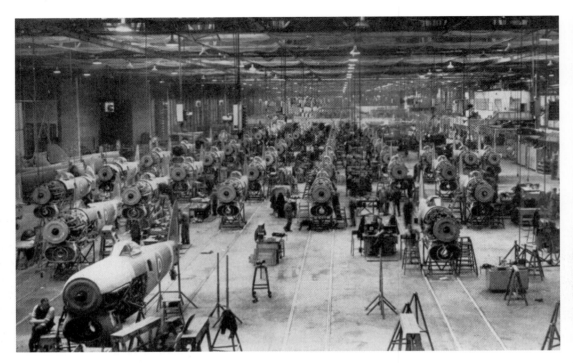

As the Allies geared up for the forthcoming D-Day landings the munitions plants were in full swing. *Above:* An assembly shop at Hawker with the Typhoon fighter in production. The Typhoon had been intended as a successor to the Hawker Hurricane. *Below:* Newly arrived in Britain, these US-built mortars are being carefully inspected and prepare for action.

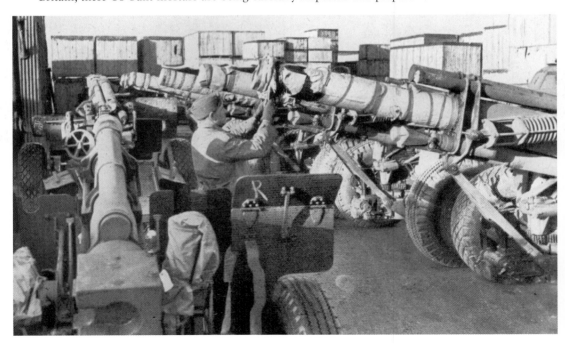

MARCH 1944

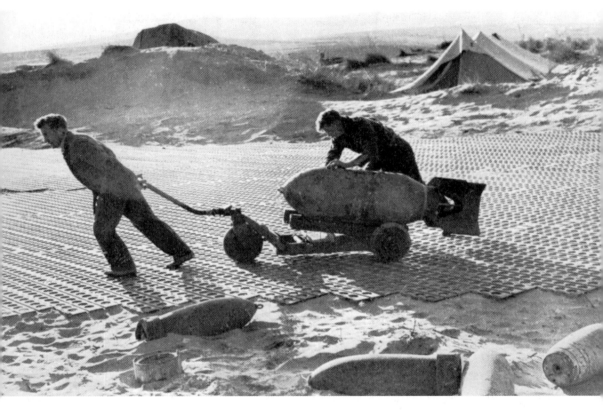

Above: A 1,000-lb bomb being hauled along a steel runway in Italy for loading on to a Kittybomber. The aircraft operated in the Eighth Army and 5th Army sectors, above the beachhead and over Yugoslavia. See the bombing range map overleaf.

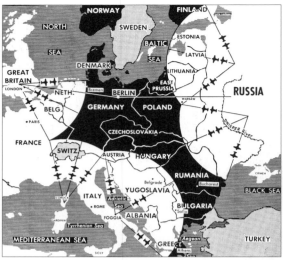

Above: Air Chief Marshall Sir Arthur Harris had vowed to bomb Berlin until 'the heart of Nazi Germany ceases to beat'. As head of RAF Bomber Command, Harris advocated the area bombing of German cities as part of the strategic bombing campaign. In addition, the advance of the Allies during 1944, linked to an increased range for the fighter escorts, dramatically increased the range of daylight bombers, which could more accurately attack specific targets. *Below:* Stacking incendiary bombs for loading on a Flying Fortress, *The Rebel*, in readiness for another attack on targets in Germany. *Opposite:* A reconnaissance photograph following a raid on Stuttgart on 20 February 1944. Smoke is rising from the Robert Bosch engineering works.

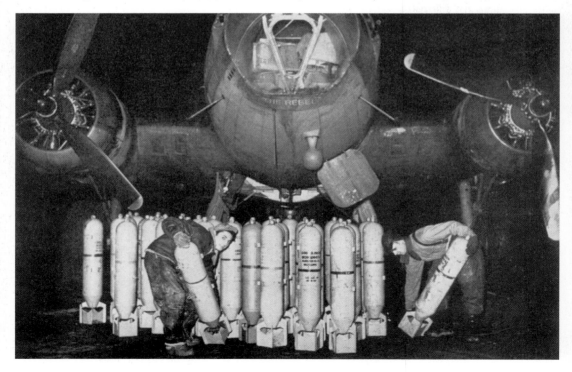

Above: Government buildings in central Berlin, including the Air Ministry, receive direct hits in a 1,500-aircraft attack by the US 8th Air Force in April 1944. The Templehof airfield, visible under the B-17 Flying Fortress, also received numerous hits.

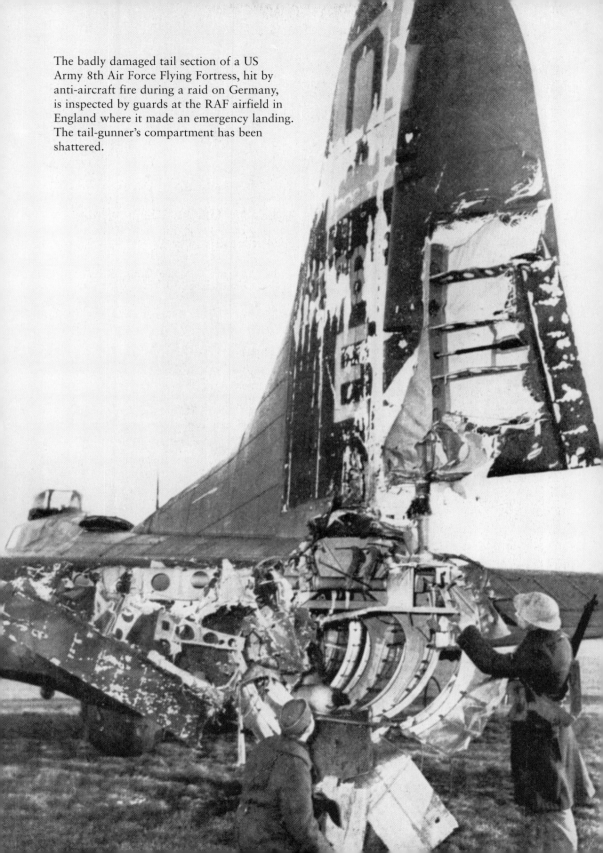

The badly damaged tail section of a US Army 8th Air Force Flying Fortress, hit by anti-aircraft fire during a raid on Germany, is inspected by guards at the RAF airfield in England where it made an emergency landing. The tail-gunner's compartment has been shattered.

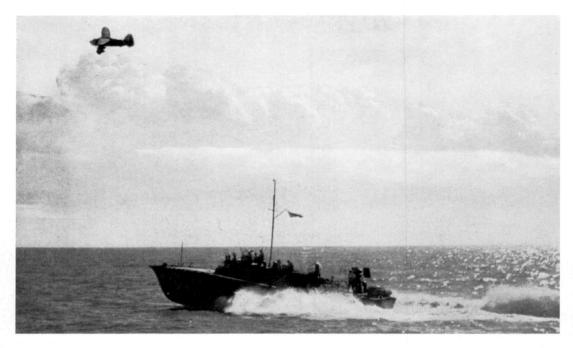

Above: An Air-Sea Rescue Lysander is seen making contact with a launch that it is guiding to the location of an airman. The Air-Sea Rescue Service was responsible for saving many airmen who had to bail out over the sea. *Below:* A flotilla of British submarines alongside a depot ship. The second vessel from the right is HMS *Upright*, which had shot down an enemy aircraft.

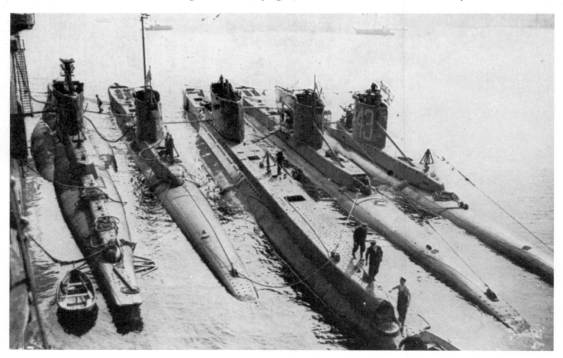

APRIL 1944

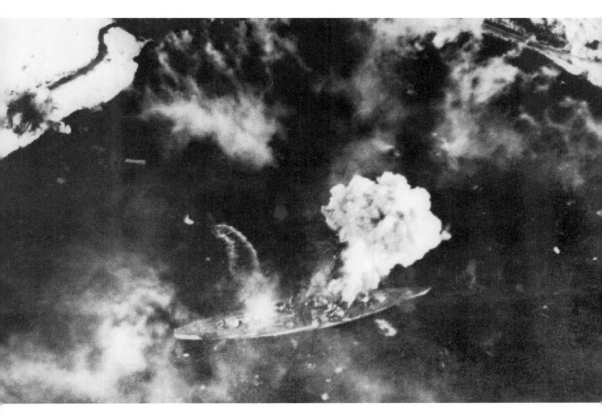

Above: On 3 April 1944 the German Bismarck-class battleship *Tirpitz* was attacked at her base in Kaajford in the far north of Norway by forty British carrier-borne Fairey Barracuda dive-bombers. Carrying 1,600 lb bombs, they attacked in two waves, killing more than 100 men and causing considerable damage to the warship with the loss of only two of the bombers. Smoke is seen billowing from the fires, but it would not be until November 1944 that a second attack finally finished the job.

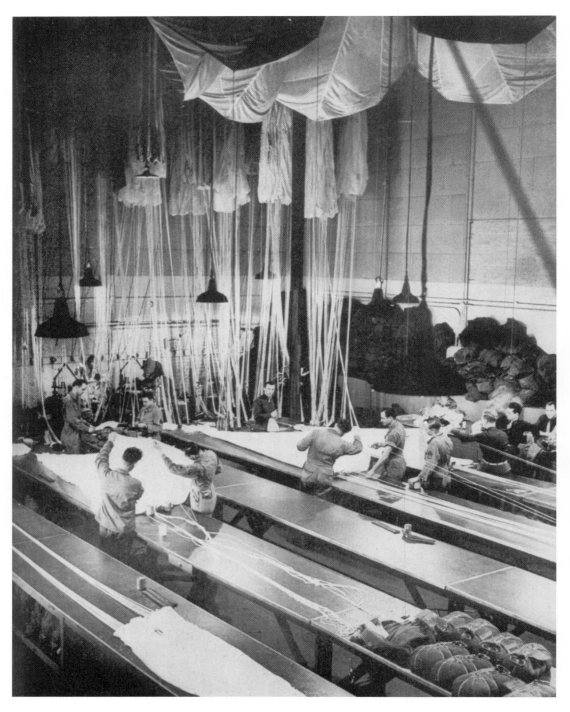

Above: Parachutes being rigged by the men of the US Service Command in Britain, which organised supplies and maintained America's airborne contribution to the invasion of Hitler's Fortress Europe.

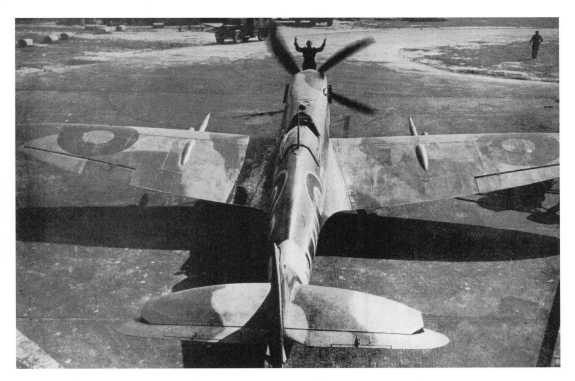

Two stalwarts of the RAF's fighter force. *Above:* Emulating the Mustangs and the Thunderbolts, Spitfires were also operational in the skies over Germany in 1944. This example is one of several Spitfires which made their first foray into Germany on 26 April. The last production Spitfire, a Mk 24, left the production line on 20 February 1948. *Below:* In contrast, the trusty Hawker Hurricane had ceased production by the summer of 1944. The last aircraft to leave the factory is shown here, bearing a banner recording its many fields of battle.

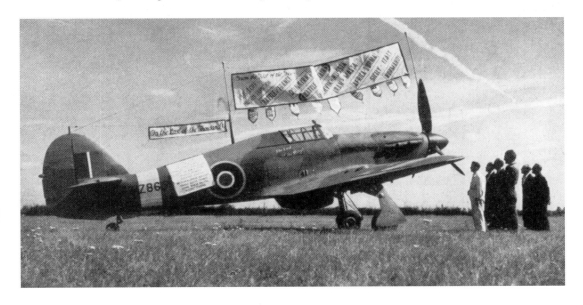

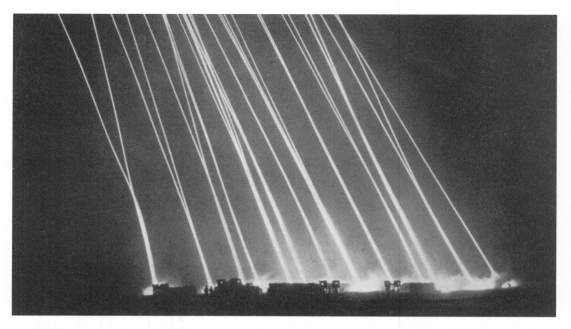

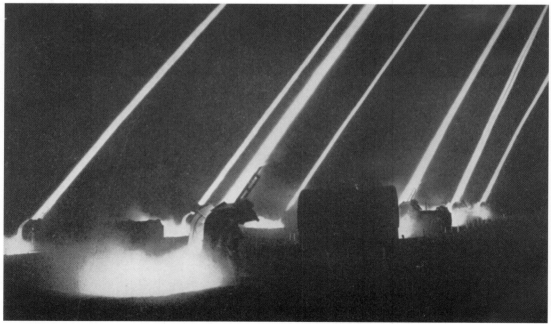

Above: A lesser-known weapon in the Allies' anti-aircraft arsenal was the Z Battery. Sometimes referrred to as anti-aircraft projectors, these multiple launchers fired 3-inch diameter solid-fuel rockets into the path of enemy bombers. An intended naval version was to have carried a trailing wire, to the end of which was attached an explosive mine. From early 1942 the operation of the land-based Z Batteries began to be transferred to the Home Guard as they were comparatively simple to operate.

Rockets
Aside from the V2 ballistic missile
– see page 140 – rockets were used in
various forms, for both offensive and
defensive purposes, by the Allies and
the Germans.

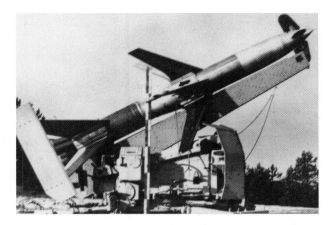

Top right: Rheintochter, for 'Rhine
Daughter', was a surface-to-air
missile developed by Rheinmetall-
Borsig. Although extensively tested
from August 1943 onwards, it was
never fired in anger and the project
was cancelled in February 1945.
It was one of several experimental
missiles developed by the Germans.

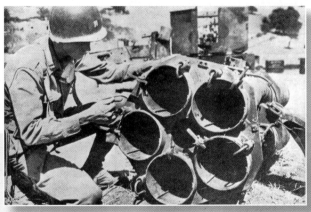

Middle right: A US soldier examines
a captured Nebulwerfer 42.
Introduced in 1942, these 'smoke
mortars' fired 21 cm and, later,
30 cm rockets from a five-tube
launcher. Both Germany and Russia
had mobile rocket launchers.

Below: The T34 Calliope Rocket
Launcher with a rack of sixty rocket
tubes mounted on a Sherman tank,
linked to the barrel to be elevated or
transversed by the tank's gunner.

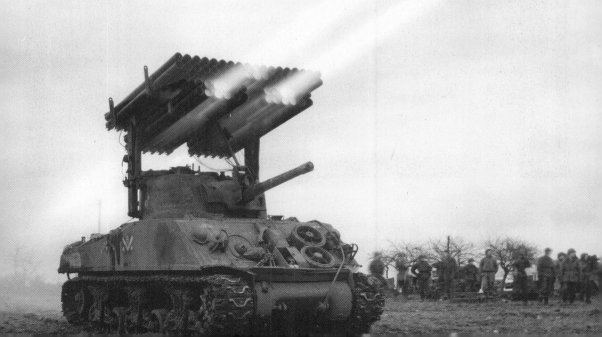

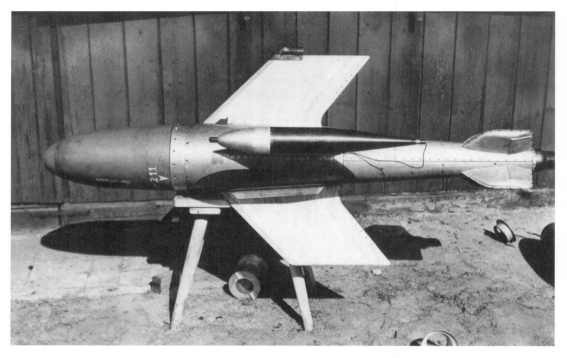

Air-to-Air Rockets
Above: The Ruhrstahl X-4 was a wire-guided air-to-air missile intended to be fired from beyond the range of an enemy bomber's guns. The missile was spin-stabilised in flight and its BMW 109-448 rocket gave it a lightning speed of 715 mph. Two bobbins, located on opposite fins, fed out the wire from the controlling aircraft. It did not see operational service, whereas the R4M rockets, shown below, were fitted to a small number of aircraft, notably the Me 262.

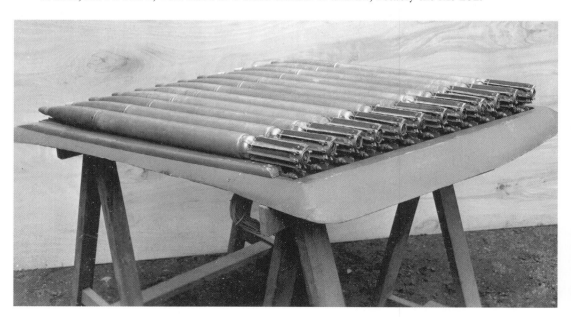

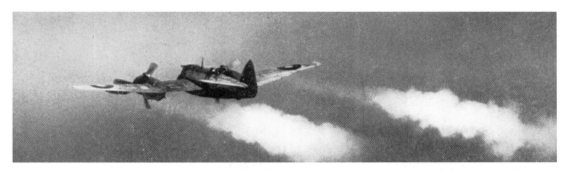

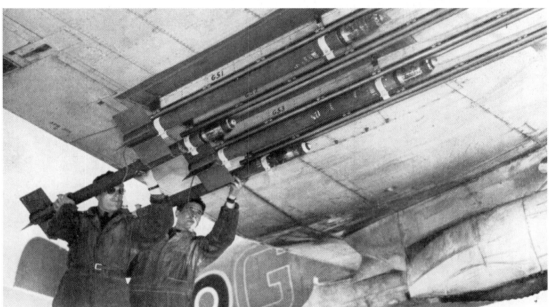

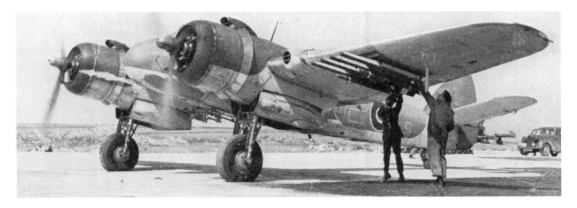

Above: The RP-3, Rocket Projectile 3-inch, was a British rocket used primarily as an air-to-ground weapon, mainly against tanks, trains and other transport targets, and also by Coastal Command and the Royal Navy against enemy submarines and shipping. They were fitted on a number of aircraft types, in particular the Typhoon, and as shown here on a Beaufighter.

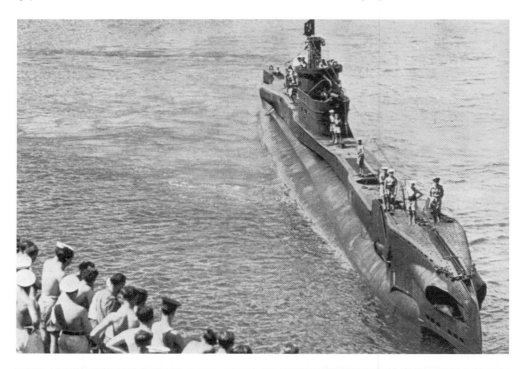

Above: A British submarine returns to base from a patrol in Far Eastern waters and is greeted by the crew of a depot ship. In the lower photograph the crew of HMS *Grenville* are fusing shells for the guns. The *Grenville* engaged with a German E-boat off the Anzio beachhead.

MAY 1944

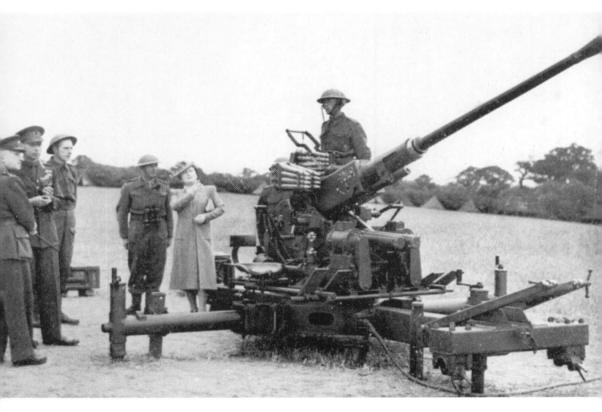

Throughout 1944, and in particular during the build-up to the D-Day landings, the king and queen continued to bolster morale with their many personal appearances at both military locations and on the home front. *Above:* A visit to an anti-aircraft site in southern England. These guns were to play a vital role in downing many of the incoming V1 flying bombs.

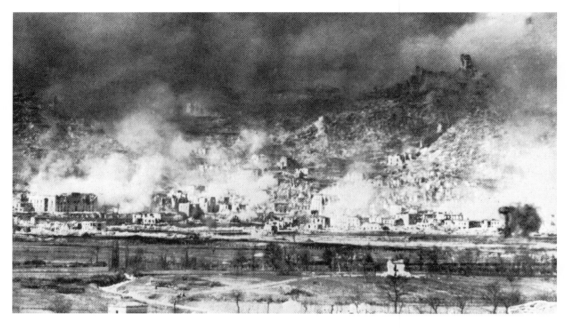

The Battle for Monte Cassino

On 18 May 1944 the German defenders were driven out of the Italian town after four months of intensive fighting, finally enabling the Allies to break through the Gustav defensive line to open the way to Rome. The Allied bombardment of Monte Cassino is shown above and, below, one of the thousand guns, a 4.2-inch mortar, is opening the barrage.

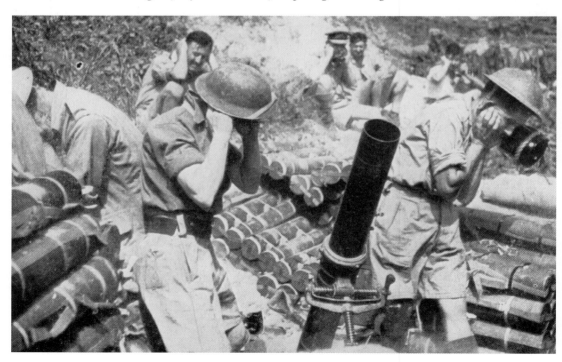

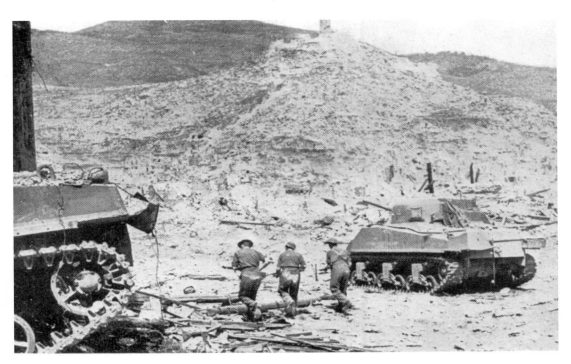

Top: Soldiers of the Eighth Army storming Monte Cassino amid a scene of utter devastation.
Bottom: British troops in the main hall of the crypt of the chapel at Monte Cassino. The hilltop abbey had provided the Germans with a commanding defensive position.

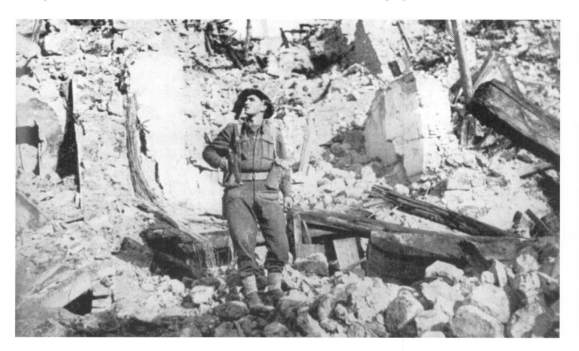

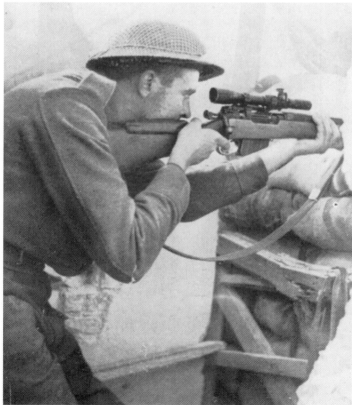

Above: A New Zealand
soldier making his way
over the rubble that fills
the streets of Cassino. He is
keeping a watchful look out
for enemy snipers.

Left: During the final stages
of fighting in the battle for
Monte Cassino, a British
sniper scans the landscape
for any signs of enemy
movement.

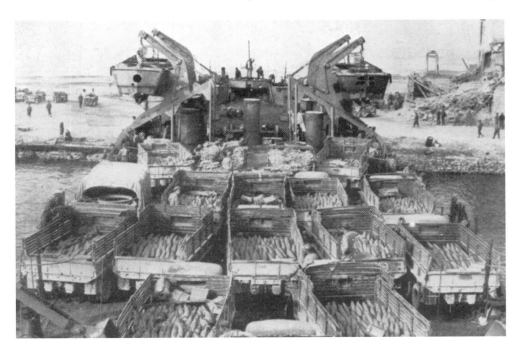

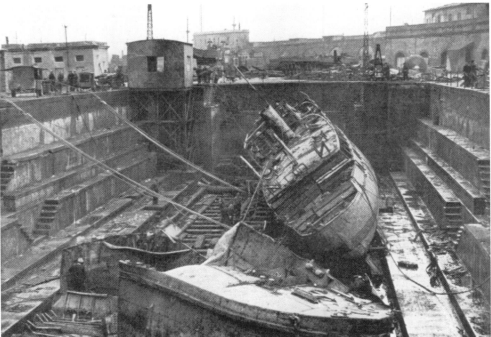

Top: Keeping the supplies flowing, an American landing craft arrives at the Anzio beachhead with a cargo of lorries laden with shells. *Bottom:* The Germans destroyed the gates of this dry dock in Naples, submerging several vessels including an auxiliary minesweeper. Engineers of the Royal Navy fitted new gates and refloated the minesweeper in eight days.

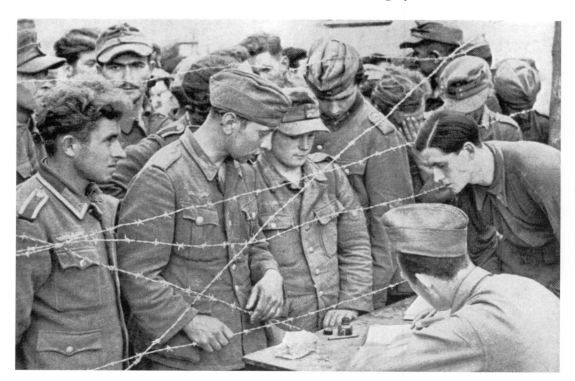

Above: Hundreds of prisoners were captured by the French in the fighting for Monte Majo and Castelforte. They are shown giving their details to a camp official. *Below:* A wounded British soldier is being taken on board a landing craft for transfer to a base hospital in Naples.

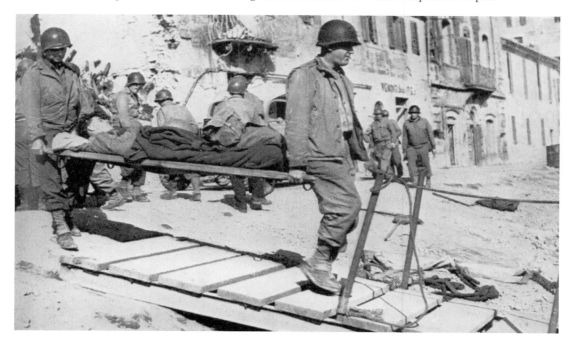

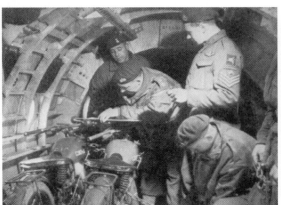

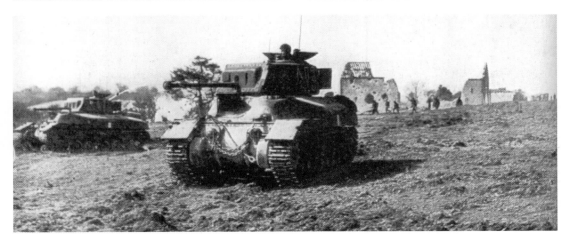

D-Day Preparations
Top: Tank landing ships being gathered. *Middle:* Airborne troops photographed during exercises and showing a transport officer checking motor-cycles made fast in a Horsa glider. *Bottom:* Canadian infantrymen follow tanks in a practice attack.

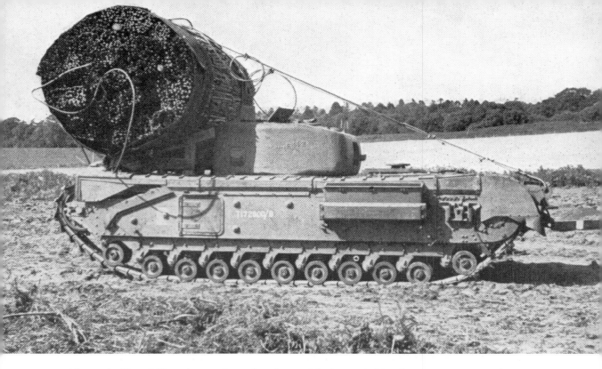

Above: A Churchill tank carrying a brushwood facine to bridge large craters or tank traps.

Hobart's D-Day Funnies

Following the disastrous amphibious landing at Dieppe in 1942, the Allies set about devising new equipment for the big one, D-Day. The British appointed an armoured warfare expert, Major-General Percy Hobart, to coordinate the development of specialist tanks to lead the assault on Normandy's beaches. The resulting family of weird and wonderful machines, mostly based on the Churchill or M4 Sherman, was collectively known as 'Hobart's Funnies'.

Some of the Funnies were drawn from existing ideas such as the chain flail to set off mines, while others required an altogether more innovative approach. Perhaps the greatest challenge was to create a swimming tank. Several ideas, usually involving floats mounted on either side, had proved unsatisfactory, and anyway would take up too much space on the LSTs (Landing Ship Tanks). In 1940 the Hungarian-born engineer Nicholas Stausser devised a flotation screen made up of waterproof canvas, which surrounded the top half of the tank. Thanks to the Archimedes principle the heavy vehicle floated, and in the water it would be propelled by propellers driven by the tank's engine – hence the name Duplex Drive or DD.

In early 1944 Hobart put on a demonstration of his progeny for the Allied top brass, including Montgomery and Eisenhower. These included the DD, the Crab mine-clearer with flailing chains, the Crocodile flame-thrower and an assortment of tanks to clear stricken tanks and to surmount obstacles. Eisenhower was delighted with the DD but the Americans declined the others.

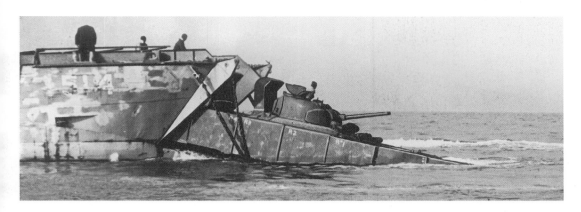

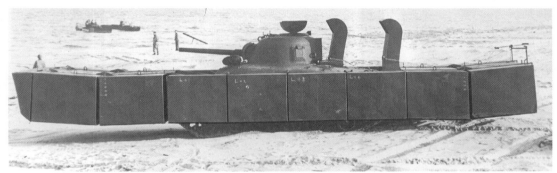

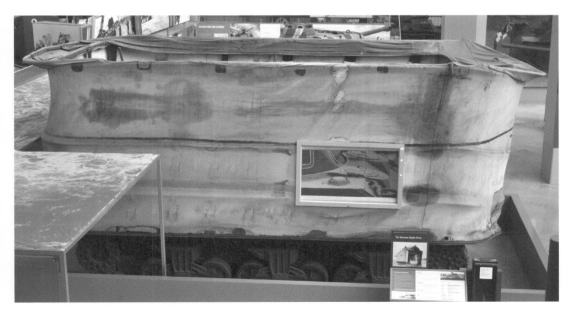

The upper two photographs show the M19, America's much bulkier alternative to the DD, which involved a 'lifebelt' of steel flotation pontoons. *Bottom:* A preserved DD amphibious Sherman with the buoyancy skirt in the raised position. The window has been cut into the skirt to allow visitors to see inside.

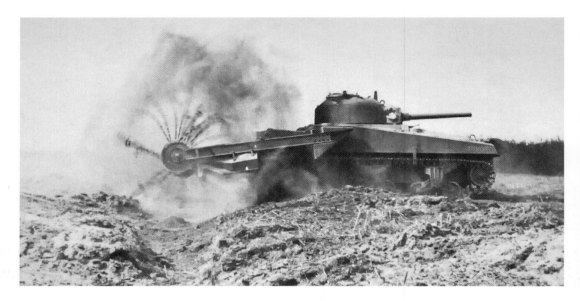

Above: A Sherman V Crab pounding the ground with its chains in a test of mine-clearing procedures for D-Day. The turret is facing backwards to keep the gun out of harm's way. *Below:* Not a Funny, this rubber tank is part of the phantom invasion force created in south-east England under Operation Fortitude South in order to fool the Germans into thinking that the landings would take place in the Pas de Calais area.

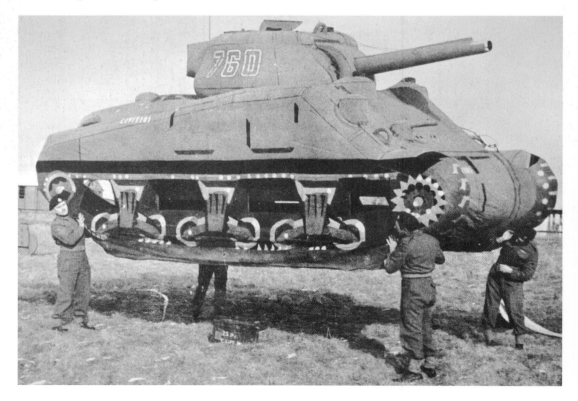

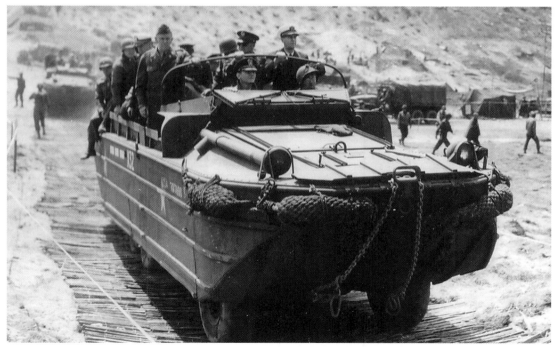

Top: A Bren Gun carrier fitted with a flame-thrower, a smaller version of the Crocodile shown in the colour section. *Bottom:* The six-wheel amphibious DUKW, or 'Duck', was an extremely useful general-purpose transport on the Normandy beaches. In this photograph, taken a few days after D-Day, a Duck is bringing Eisenhower and his top officers ashore.

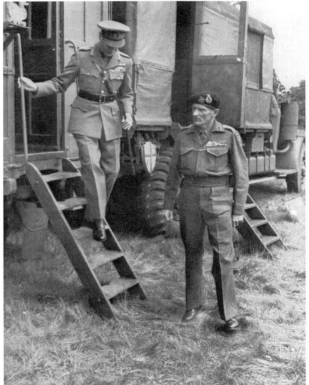

Above left: Wartime rail travel was always challenging, but as D-Day neared the pressure on the network was growing and travellers were urged to 'stay put this summer'.

Above right: 'Room for one', a cartoon depicting the plight of the ordinary rail traveller. 'All right, but promise to lift me down when I reach my station.'

Left: On 22 May the king paid a visit to the headquarters of the British Commander-in-Chief, General Sir Bernard Montgomery. He was shown around the general's mobile HQ and is shown leaving one of the caravans.

Opposite page: The king is also shown discussing the progress of the campaign with the Allied Supreme Commander, Dwight D. Eisenhower, and again with Montgomery, this time a few months later in Normandy. Note that the king is in battledress.

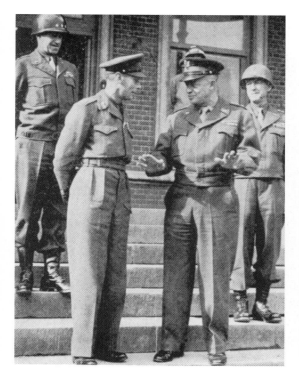

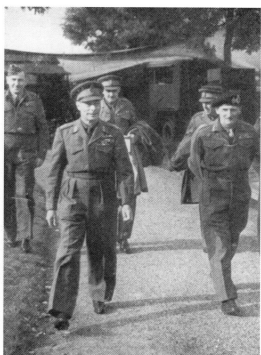

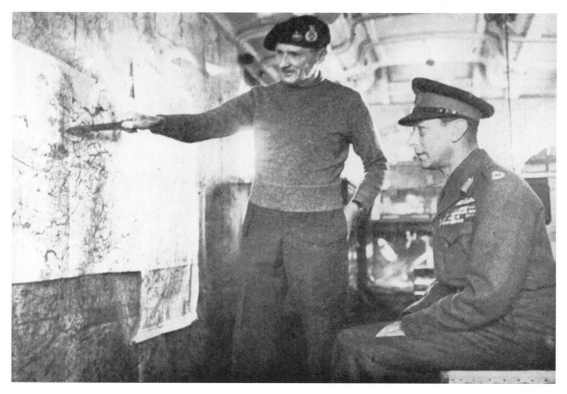

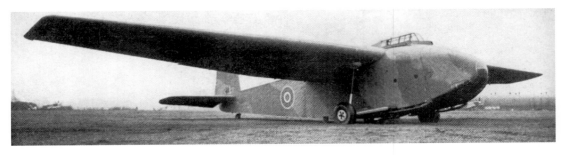

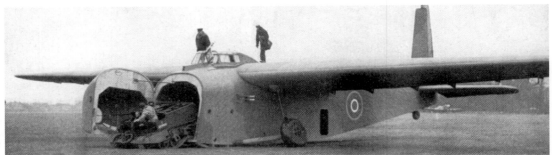

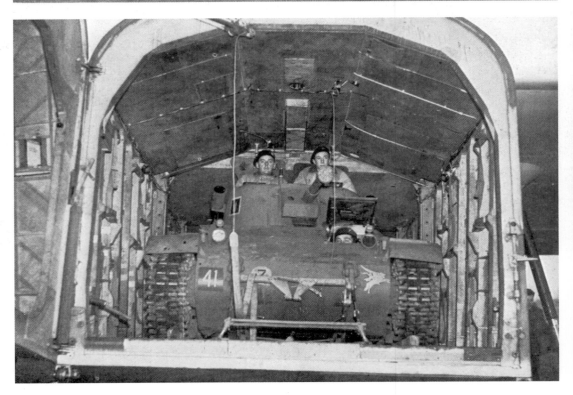

Above: The Hamilcar glider, which carried supplies and vehicles to Normandy and later to Arnhem. Towed at 150 mph by a four-engined bomber, it could carry one light tank, two Bren Gun Carriers or armoured cars. In the bottom view an American Locust tank has been loaded.

JUNE 1944

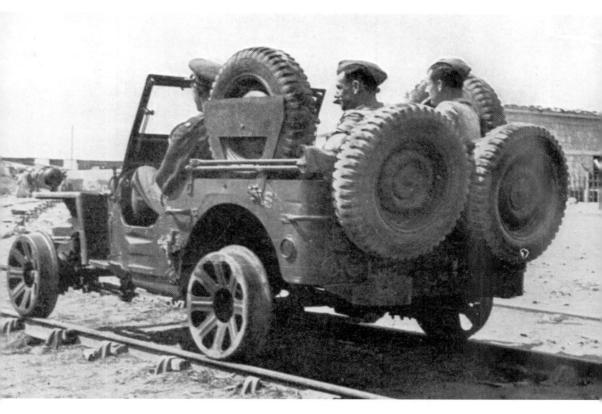

Above: This Jeep has been converted to run on rails as well as on the roads. The road wheels are carried on board. However, practical applications must have been very limited.

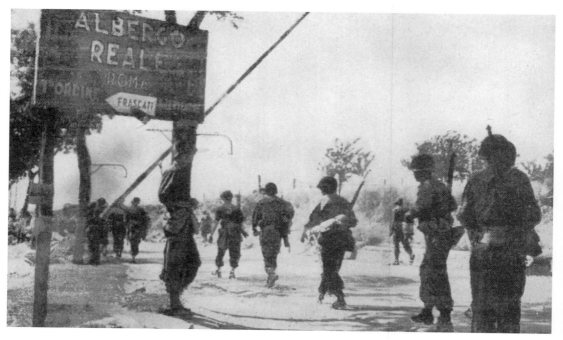

Rome is Occupied

Above: Troops of the 5th Army entering the suburbs of Rome. The city was occupied at 9.15 p.m. on the night of 4 June 1944. *Below:* The inhabitants of Rome greet the Allied soldiers as liberators. The locals are shown cheering the Americans as they pass through the city in Jeeps. General Mark Clark is seated in the rear vehicle.

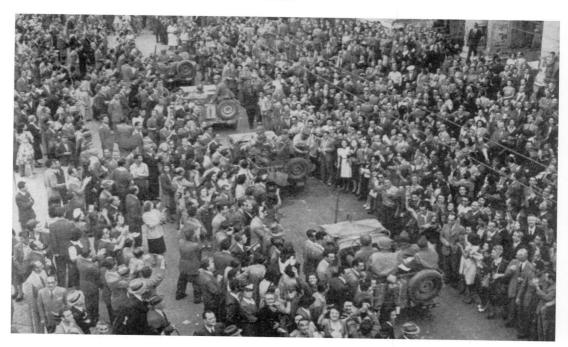

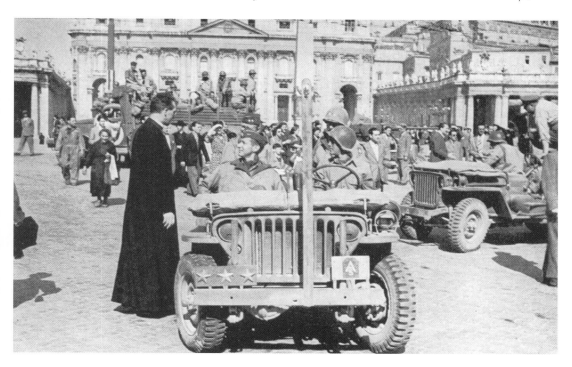

Above: General Mark Clark, Commander of the 5th Army, talking to a priest in front of St Peter's Cathedral. *Below:* A US Sherman tank passes another of Rome's famous landmarks.

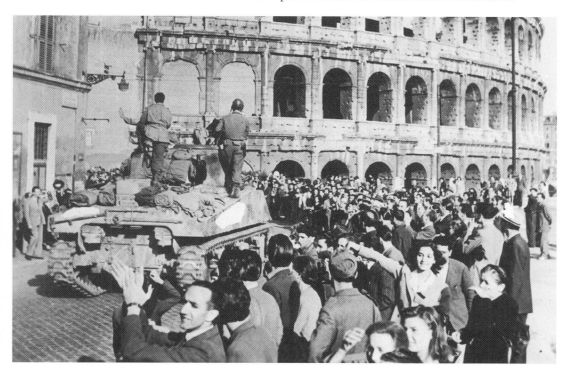

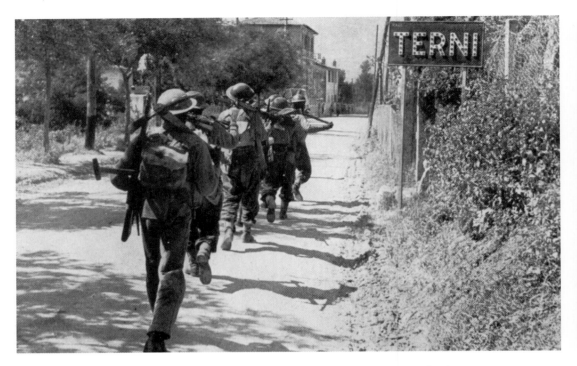

Above: A party of Indian troops in the main thoroughfare of Terni, which was cleared of enemy forces on 14 June.

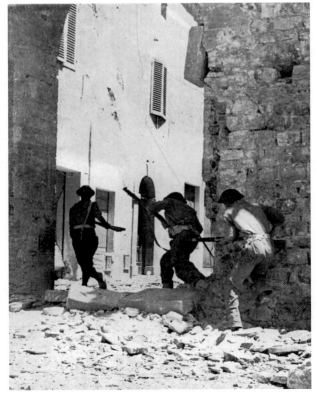

Left: Mopping-up operations in Castiglione in the Lake Trasimeno area. Moving cautiously and taking advantage of all available cover, these British soldiers search out stray German elements remaining in the town, which was taken on 26 June.

Two examples of bridges built by a Field Company of the Royal Engineers. A triple-tier bridge and, bottom, an artillery observation tank crossing a Bailey bridge. These structures replaced bridges blown up by the retreating Germans just outside Orvieto.

**SUPREME HEADQUARTERS
ALLIED EXPEDITIONARY FORCE**

Soldiers, Sailors and Airmen of the Allied Expeditionary Force!

You are about to embark upon the Great Crusade, toward which we have striven these many months. The eyes of the world are upon you. The hopes and prayers of liberty-loving people everywhere march with you. In company with our brave Allies and brothers-in-arms on other Fronts, you will bring about the destruction of the German war machine, the elimination of Nazi tyranny over the oppressed peoples of Europe, and security for ourselves in a free world.

Your task will not be an easy one. Your enemy is well trained, well equipped and battle-hardened. He will fight savagely.

But this is the year 1944! Much has happened since the Nazi triumphs of 1940-41. The United Nations have inflicted upon the Germans great defeats, in open battle, man-to-man. Our air offensive has seriously reduced their strength in the air and their capacity to wage war on the ground. Our Home Fronts have given us an overwhelming superiority in weapons and munitions of war, and placed at our disposal great reserves of trained fighting men. The tide has turned! The free men of the world are marching together to Victory!

I have full confidence in your courage, devotion to duty and skill in battle. We will accept nothing less than full Victory!

Good Luck! And let us all beseech the blessing of Almighty God upon this great and noble undertaking.

Dwight D Eisenhower

Eisenhower's statement to the soldiers, sailors and airmen of the Allied Expeditionary Force.

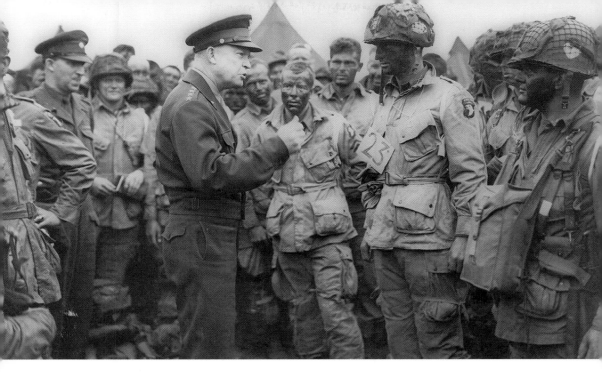

Above: On the evening of 5 June, the day before D-Day, General Eisenhower talks with US paratroopers of the 502nd Parachute Infantry Regiment, 101st Airborne Division, before they board their aircraft at Greenham Common airfield. It is said that Ike liked to talk about fly fishing with the men. *(US LoC)*

Operation Overlord – The 'Great Crusade'

It was the largest invasion force the world had ever seen. On the night of 5 June 1944, an armada of 7,000 vessels, carrying an army of around 160,000 troops and their equipment, set sail from southern England heading for the beaches of Normandy. Operation Overlord was the most crucial military operation of the entire war. It was a huge gamble for the Allied commanders, who relied on years of careful preparation, training and the development of the right tools to get the job done. Failure was inconceivable, while success would establish a vital bridgehead leading to the liberation of occupied Europe and the defeat of Nazi Germany.

The Supreme Allied Commander of the Allied Expeditionary Force (SHAEF) was General Dwight D. Eisenhower. Shown opposite is his statement to the servicemen taking part in the D-Day invasion:

Soldiers, Sailors and Airmen of the Allied Expeditionary Force! You are about to embark upon the Great Crusade, toward which we have striven these many months. The eyes of the world are upon you. The hopes and prayers of liberty-loving people everywhere march with you. In company with our brave Allies and brothers-in-arms on other Fronts, you will bring about the destruction of the German war machine, the elimination of Nazi tyranny over the oppressed peoples of Europe, and security for ourselves in a free world...

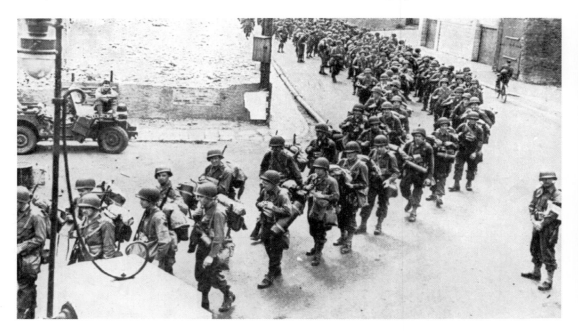

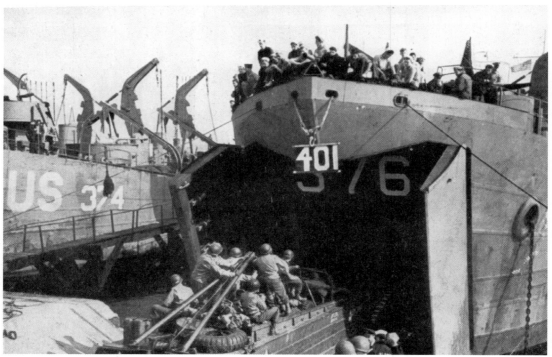

Top: US troops march through an embarkation port on the day before D-Day, 6 June 1944.
Bottom: Taking a DUKW aboard one of the landing craft. The Allied force consisted of 154,000
soldiers, of which the US contingent was 73,000 and the British and Canadian Second Army
consisted of 83,115 men, 61,715 of them British.

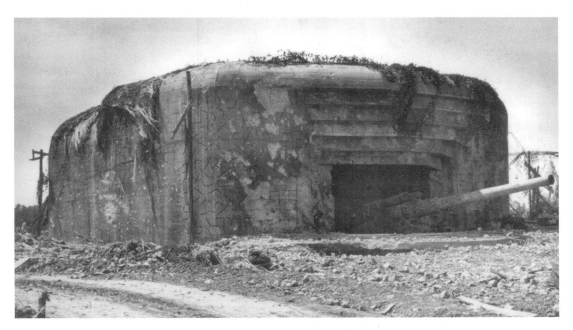

The Atlantic Wall

Hitler had hoped to keep the Allies out of northern Europe by constructing a string of fortified defences known as the Atlantikwall. However, as Erwin Rommel, who had been put in charge of the defences, noted, the wall was not a continuous structure and in many places it was still unfinished.

Top: A typical concrete gun emplacement.

Above left: A US soldier stands beside an uncompleted bunker showing the exposed steel rods and shuttering for the concrete.

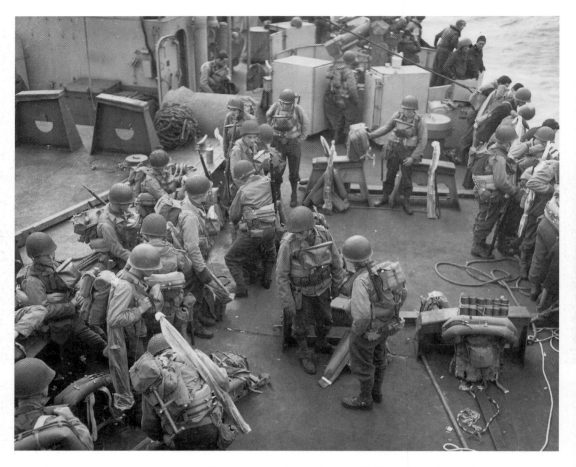

Above: A moment of calm for US soldiers on the deck of a US Coast Guard assault transport ship on the Channel crossing.

Opposite page, top: The first wave of Americans landing at Omaha Beach. The landing area was divided into zones, each one allocated a codename. The Americans would land on Utah Beach and on Omaha Beach, while the British and Canadian zones were divided into three: Gold, Juno and Sword Beaches.

Opposite page, bottom: 'Taxis to Hell – and Back – Into the Jaws of Death.' The most famous photograph from the D-Day landings, it shows a LCVP (Landing Craft, Vehicle, Personnel) from the Coast Guard-manned USS *Samuel Chase* disembarking troops of Company E, 16th Infantry, 1st Infantry Division, on to Omaha Beach on the morning of 6 June 1944. 'Enemy fire will cut some of them down,' stated the original caption for the photograph. And indeed, during the initial landing two-thirds of Company E became casualties. The photograph was taken by Robert F. Sargent, a chief photographer's mate in the US Coast Guard.

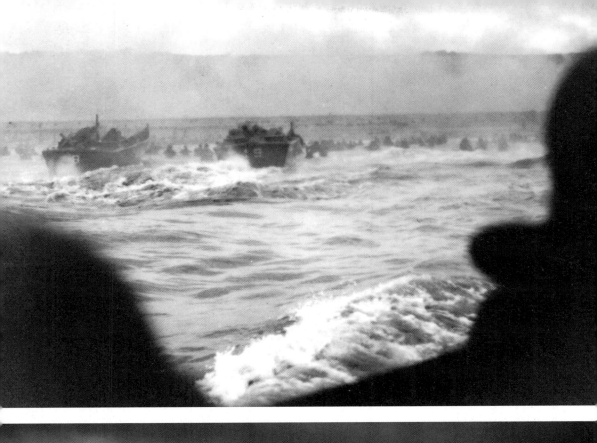
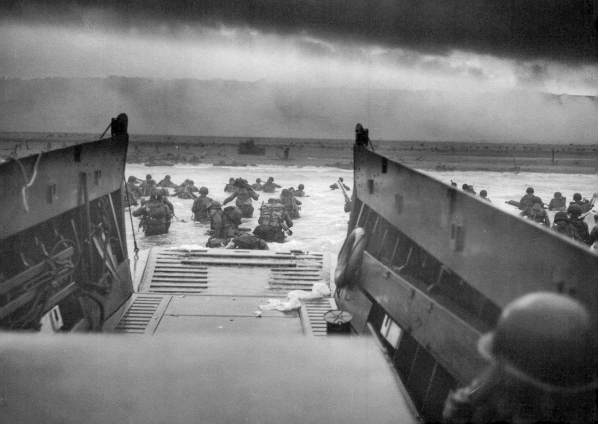

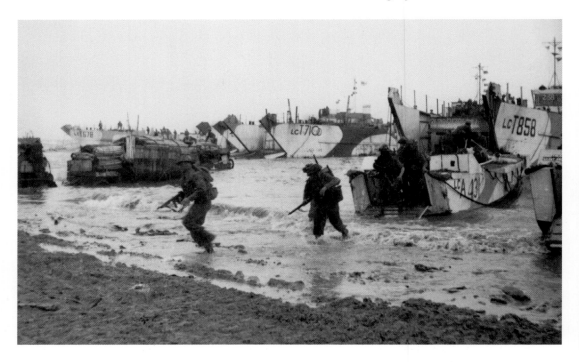

Above: British and Canadian troops wade ashore from the ramps of their landing craft. *Below:* A dramatic aerial view of Omaha Beach showing the small landing craft at the shoreline.

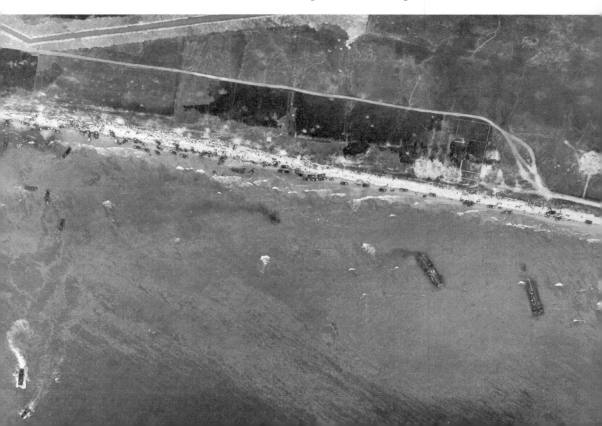

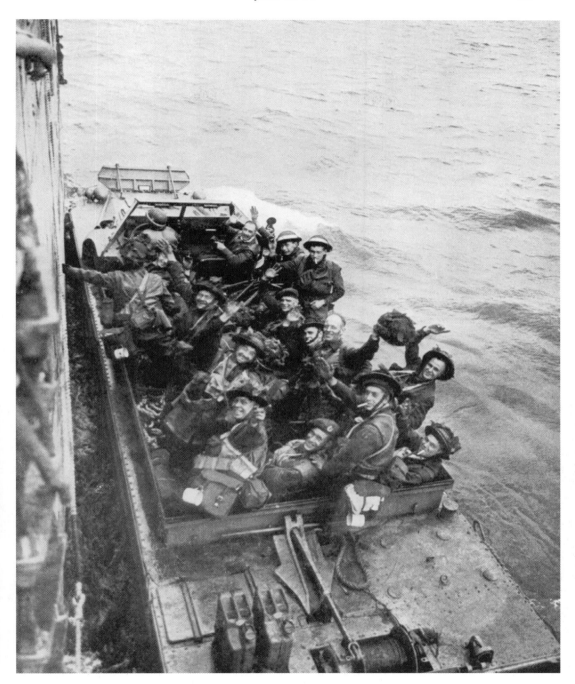

Above: British troops going ashore in a DUKW. At the time one report said, 'Large numbers of coastal batteries having been put out of action, and with little interference by German naval and air forces, the first landings were successfully effected and the beaches were soon cleared of the enemy.' Combined Allied casualties on that first day were more than 10,000, and of those 4,414 were confirmed dead. It is estimated that the Germans lost 1,000 men.

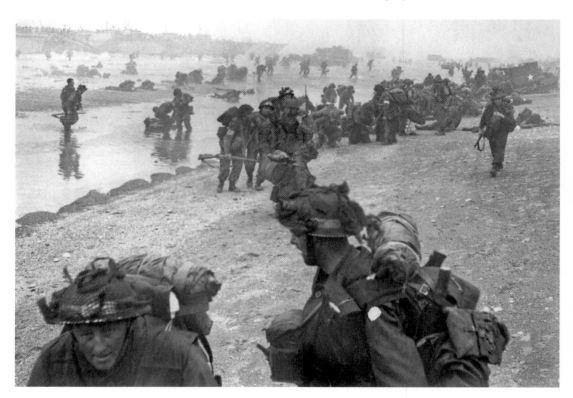

Above: British troops on the beach, many of them wounded. *Below:* Lending a hand to survivors from a landing craft which had been sunk off Utah. *(NARA)*

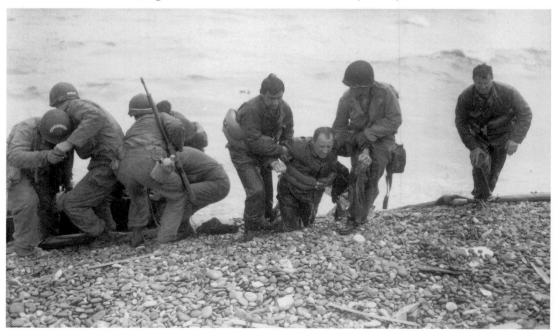

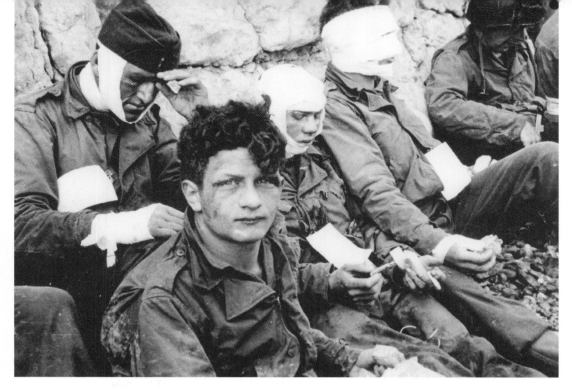

Above: Injured troops of the 3rd Battalion, 16th Infantry Regiment, 1st US Infantry Division, who stormed Omaha Beach, wait for evacuation to a field hospital. *Below:* A fallen soldier on Omaha, with rifles arranged in the form of a cross in a tribute from his comrades.

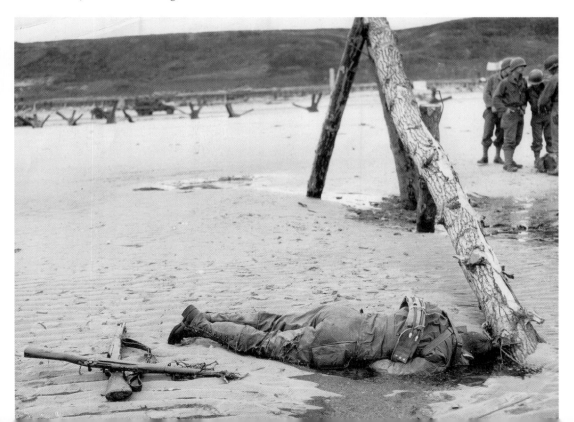

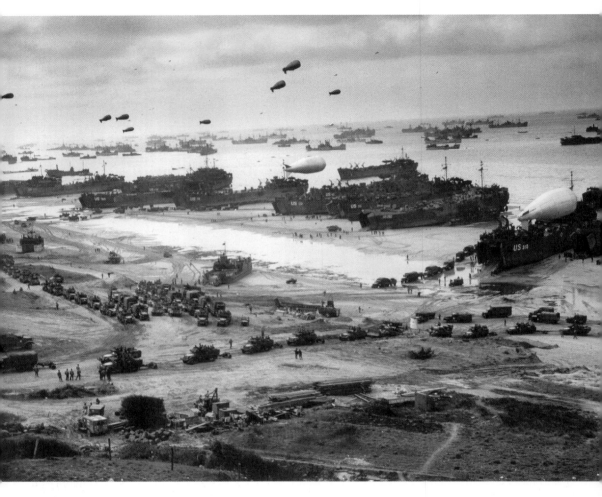

Above: Putting supplies ashore on Omaha Beach at low tide. The two Mulberry harbours at Omaha and Arromanches were not in place until 9 June, three days after D-Day. The barrage balloons are smaller versions of those that protected London, but they served a similar purpose in deterring low-flying attacks by enemy aircraft. Almost without exception the vehicles on the beach are either halftracks or lorries.

Opposite page: Two photographs of German prisoners under guard. Shown top, Canadian troops with their captives on Juno Beach. *(Archives Nationales du Canada)* In the bottom photograph Canadian casualties are being attended to in the background, while their comrades stand over another small group of prisoners.

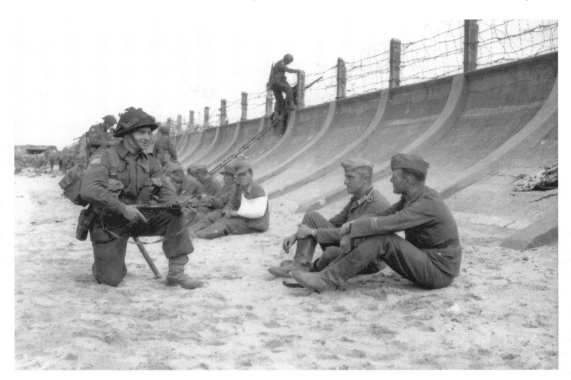

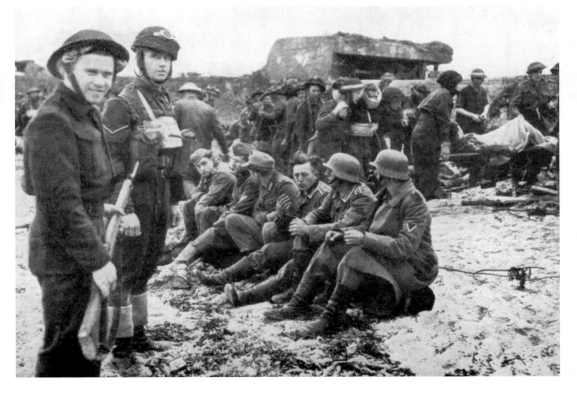

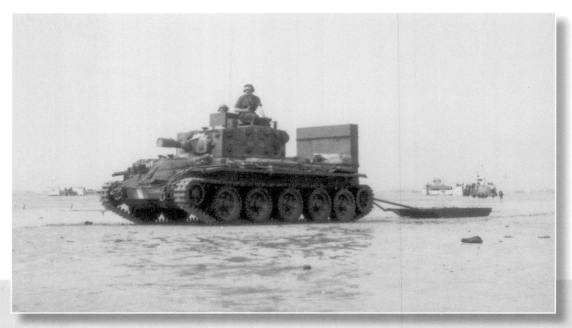

Above: A Centaur IV tank of the Royal Marine Support Group towing an ammunition sled. *Below:* 'Beach secured', a beachhead monument to the fallen. *(NARA)*

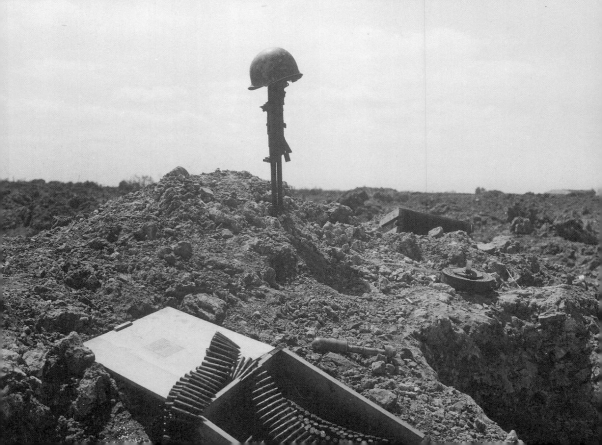

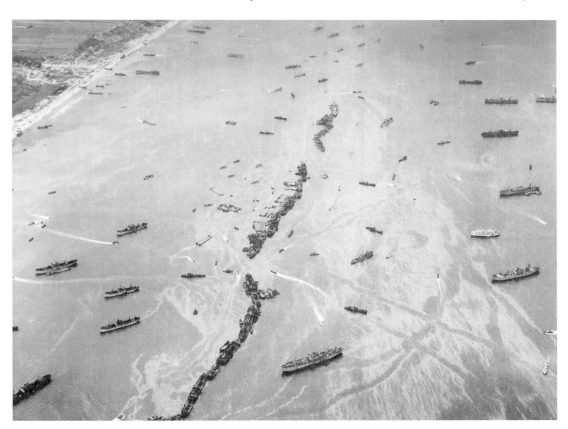

Above: US Liberty ships, known as 'Corn Cobs', deliberately sunk to create a makeshift breakwater. *(NARA) Below:* LST-21 unloads British tanks and trucks on to a 'Rhino' ferry on Gold Beach. The Rhino was a floating platform built of steel pontoons joined together and equiped with outboard engines. Their shallow draft was well suited for the beaches. *(US Navy)*

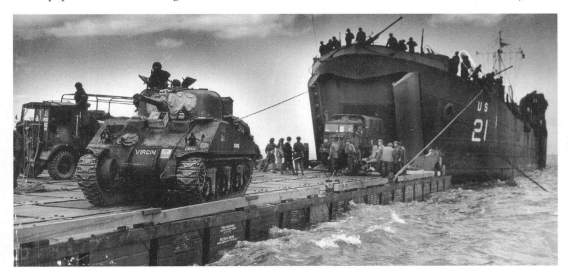

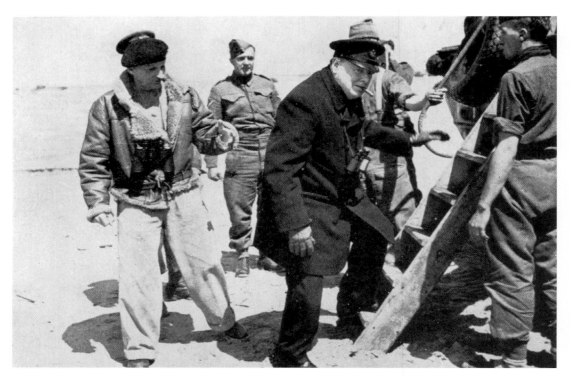

Above: On 12 June Winston Churchill, accompanied by Field Marshal Smuts, landed in Normandy and toured the beachhead in a Jeep. He is shown here dismounting from a DUKW to be met by General Montgomery. *Below:* A landing barge equipped as a kitchen, stationed in Normandy to supply meals to the crews of the many small vessels.

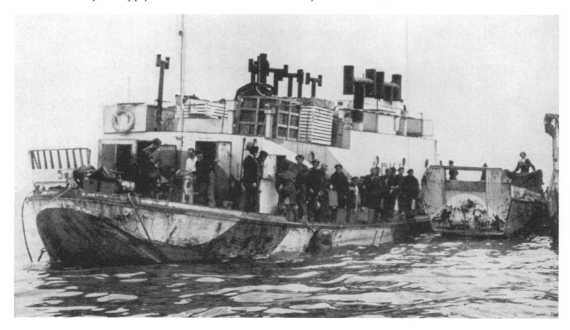

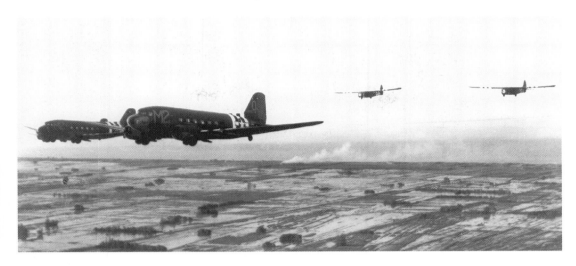

In addition to the amphibious landings, thousands of airborne troops were dropped in Normandy by parachute or landed by gliders. US paratroops were dropped behind Utah Beach to secure transportation links, and British and Canadian troops arrived by glider to capture two river and canal crossings, including the famous Pegasus bridge. *Above:* US Douglas C-47s towing Waco CG gliders. *Below:* Hamilcar and Horsa gliders landing in Normandy.

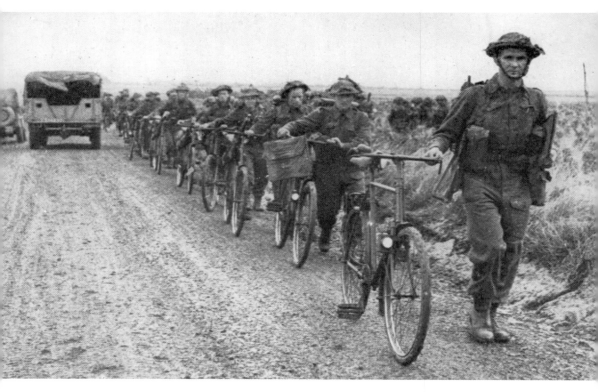

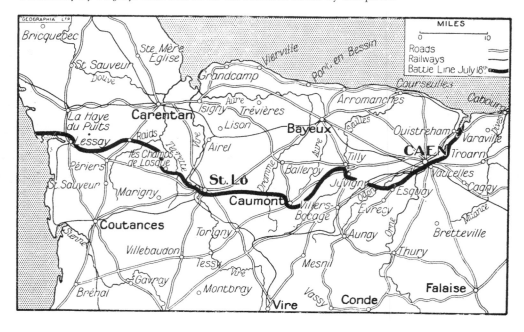

Above: Men of the cycle detachment of the Royal Warwickshire Regiment pass along a country lane in Normandy. *Below:* This map shows the approximate position of the battle front in Normandy by 18 July. Caen and St-Lô are in Allied hands by this point.

The advance through Normandy saw the first tank-on-tank clashes in Europe since the early stages of the Blitzkrieg. *Above:* This highly dramatised encounter at Villers-Bocage was published in a wartime magazine, although the British Cruiser tank, on the left, would have been hopelessly out-gunned by the Tiger. *Below:* This American M3 Stuart light tank has been fitted with dozer teeth at the front to deal with the thick hedgerows known as *bocage*.

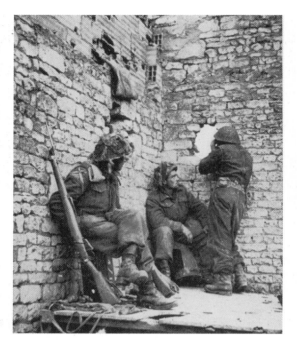

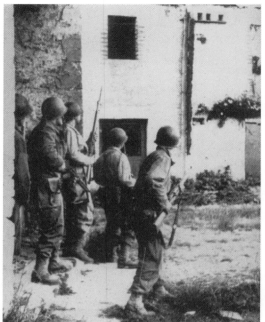

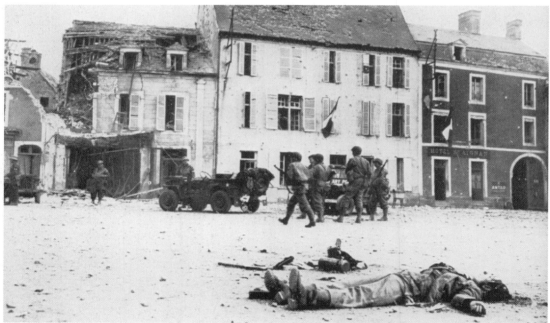

The Battle of Cherbourg
Throughout June the Allies were engaged in a hard-fought campaign to push northwards from the beachheads though the Cherbourg Peninsula to take the port itself. *Top left:* Canadian troops at an advanced post. *Top right:* US soldiers moving cautiously towards an enemy-occupied farmhouse. *Bottom:* American military police in Trévières, captured on 10 June.

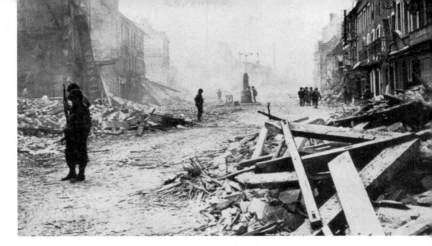

Top right: The scene of desolation that met US troops when they entered Isigny, which was captured on 9 June. This photograph shows the soldiers in the main street of the town.

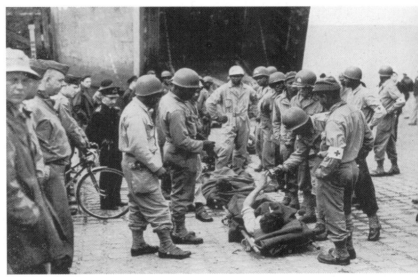

Middle right: When some 300 American wounded from the Cherbourg operations arrived by ship in England, the stretcher cases were placed on the quayside to await transport to hospitals.

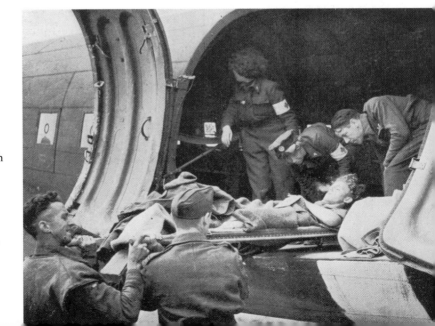

Bottom right: A British casualty is placed aboard a Douglas Dakota aircraft for the journey back to England. WAAF orderlies attend to the wounded men.

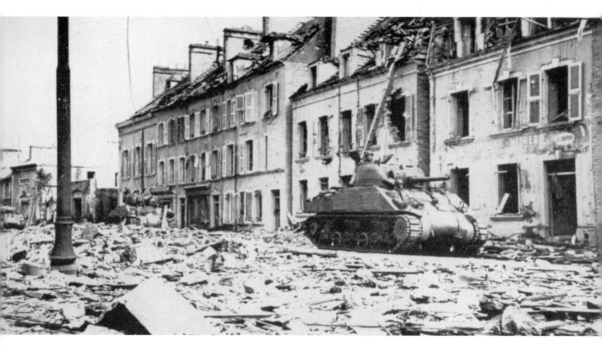

Above: An American tank unit entering Cherbourg. The destruction to the town had been caused by Allied naval bombardment and artillery fire. *Below:* The bodies of German troops who died trying to defend the town.

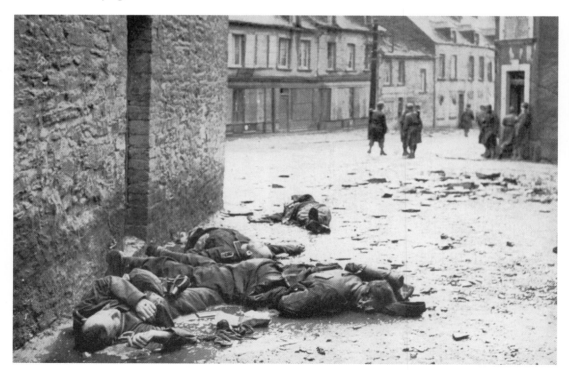

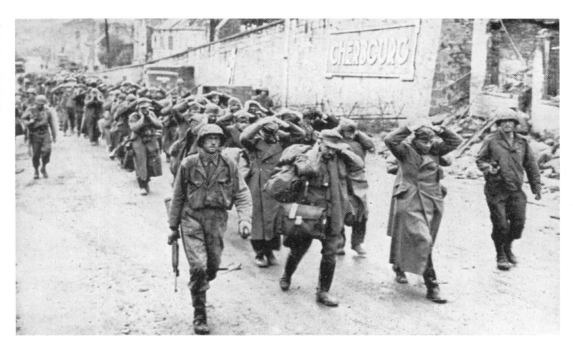

Above: A column of German prisoners being marched through the streets of Cherbourg under armed guard. It is estimated that around 35,000 were taken prisoner by the Allies. *Below:* American troops help locals tear down the sign on the Organisation Todt offices. *(NARA)*

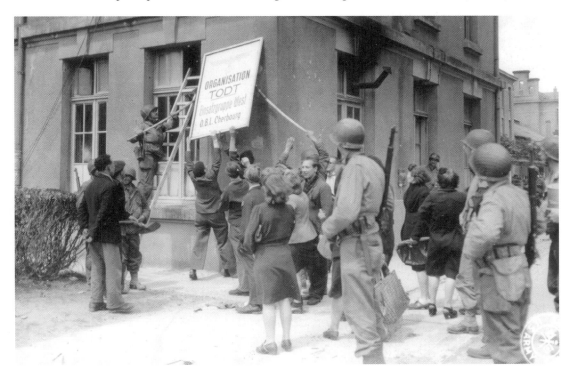

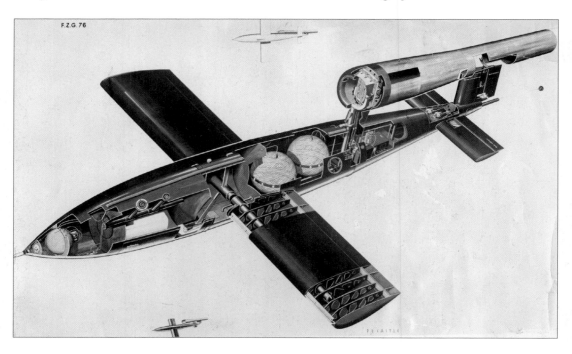

The V1 Vengeance Weapon

The first of the V weapons to be deployed was the V1 flying bomb. Known by the British as the Doodlebug or Buzz-bomb, it was a pilotless aircraft with a wingspan of 17.6 feet and just over 27 feet from nose to tail. The fuselage was of welded sheet steel and the wings were constructed from plywood and slotted on to a metal spar extending from the fuselage. The payload, 1,900 lb of Amatol-39 explosive, was contained in the warhead, and propulsion was via a tube-like engine supported at the rear on a small tail. This was an Argus pulsejet, a type of engine sometimes referred to as a resonant jet. In flight, fuel was drawn past hinged flaps at the front of the pipe by the aircraft's forward motion. Initial ignition was by an automotive spark-plug, but once it got going each pulse of fuel, coming at a rate of fifty per minute, was ignited by the heat of the previous one. The V1 launched on an inclined ski-ramp, the missile mounted on a trolley fired by a steam catapult, and by the end of 1943 around 100 ramps were under construction in northern France.

The first V1 attack on London took place on 12 June 1944, just days after D-Day. The attacks soon intensified and at their height more than a hundred V1s were hurtling across the Channel every day. People living in London and the south-east soon became familiar with the drone of their engines, and the terrifying silence which meant the engine had cut out and the bomb would fall. By the end of August 1944, anti-aircraft guns were destroying around 80 per cent of the V1s in the air, and to back them up a field of 2,000 barrage balloons were deployed to the south-east of the capital. Aircraft interception accounted for more than 1,000. Approximately 9,500 V1s were launched against London and 23,000 people lost their lives.

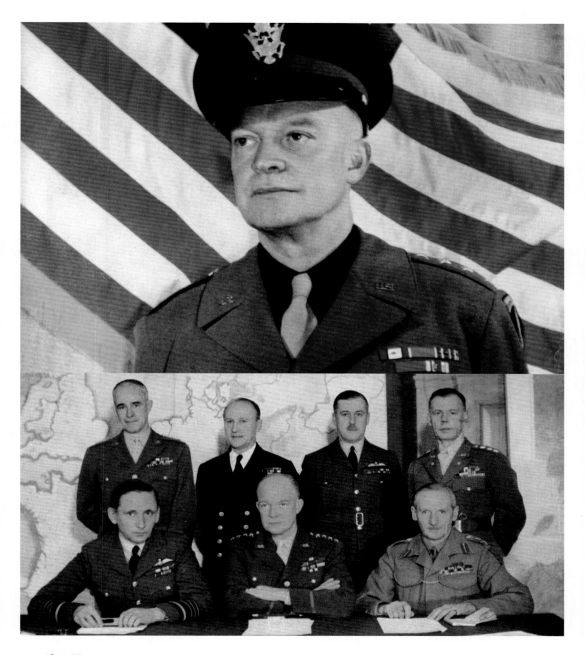

Ike's Team

The appointment of Major-General Dwight D. Eisenhower, *top*, as Commander of US forces in Europe was announced in June 1942. Having commanded the Allied landing in North Africa, he became Allied C-in-C North Africa in February 1943. His appointment as Supreme Commander of the Allied Expeditionary Force for the liberation of Europe came in December 1943. *Bottom:* The men who were to lead the Allied forces, left to right, front row; Air Chief Marshal Sir Arthur Tedder, (Eisenhower) and General Sir Bernard Montgomery. Standing; Lieutenant-General Omar Bradley, Admiral Sir Bertram Ramsey, Air Chief Marshal Sir Stafford Leigh-Mallory and Lieutenant-General Walter Smith (US Army Chief of Staff to General Eisenhower).

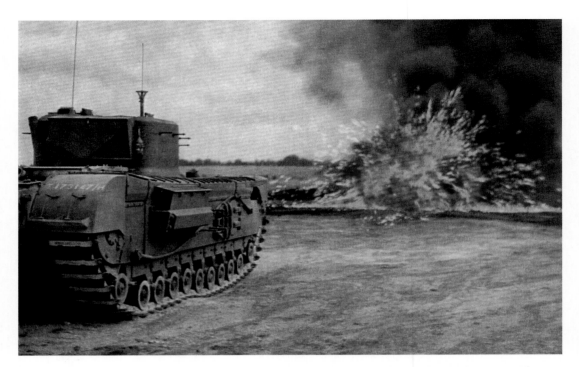

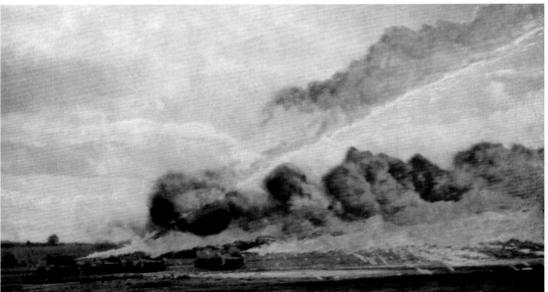

D-Day Preparations

In preparation for Operation Overlord the British developed a range of special machines, usually modified Sherman or Churchill tanks, which became known as 'Hobart's Funnies' after the army officer in command of the project, Major-General Percy Hobart. *Above:* Two images of a 'Crocodile', a Churchill tank fitted with a flame-thrower. It towed an armoured trailer carrying 400 gallons of fuel. The flame-thrower had a range of 120 yards and was said to be highly effective in clearing bunkers and other fortifications.

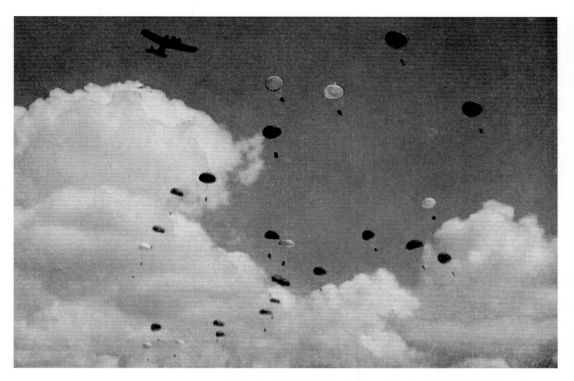

British paratroopers undergoing training by RAF instructors of the Army Co-operation Command. On D-Day these airborne troops were carried up to 200 miles inland prior to the seaborne landings in order to secure key points behind the Germans' coastal defences.

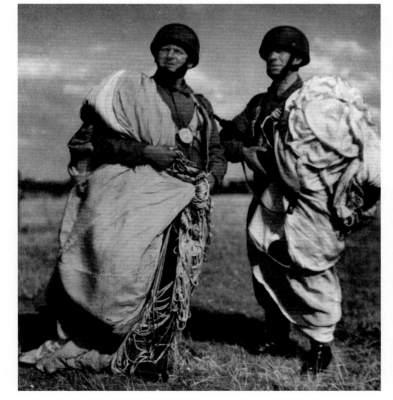

Right: Two parachutists after a training drop, with their practice 'chutes draped around them, watching as the others descend.

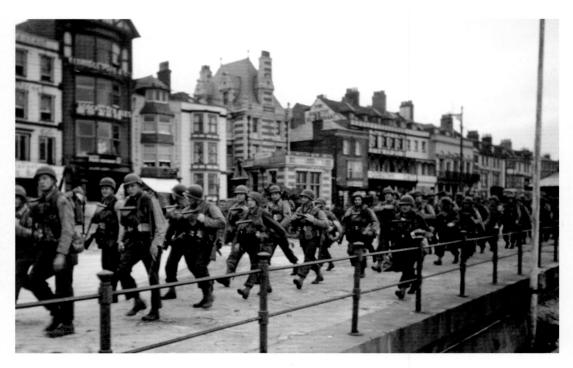

Above: 'These American troops are marching through the streets of a British port town to the docks where they will be loaded into landing craft for the big assault.' The town is Weymouth, on the south coast of Dorset, the men are US Rangers boarding the flotilla of vessels for the D-Day landings on the beaches of Normandy. *Below left:* Driving a Jeep into the open doors of an LCT. *Below right:* Vessels loading in Weymouth harbour.

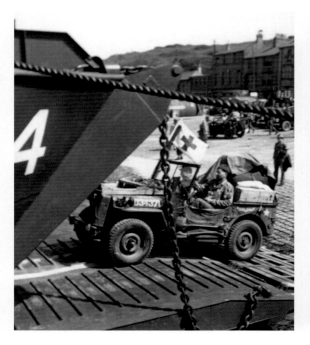

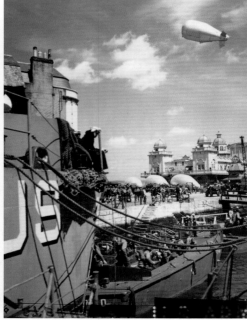

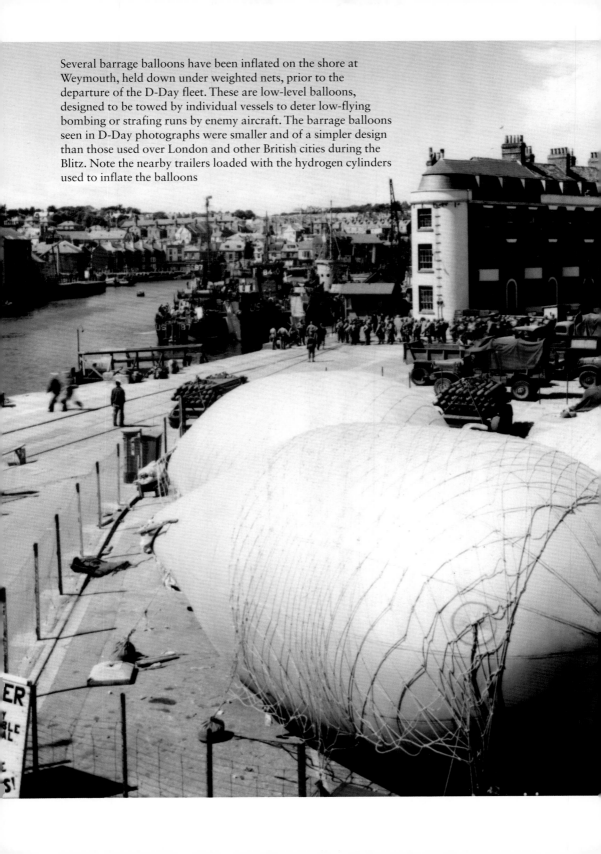

Several barrage balloons have been inflated on the shore at Weymouth, held down under weighted nets, prior to the departure of the D-Day fleet. These are low-level balloons, designed to be towed by individual vessels to deter low-flying bombing or strafing runs by enemy aircraft. The barrage balloons seen in D-Day photographs were smaller and of a simpler design than those used over London and other British cities during the Blitz. Note the nearby trailers loaded with the hydrogen cylinders used to inflate the balloons

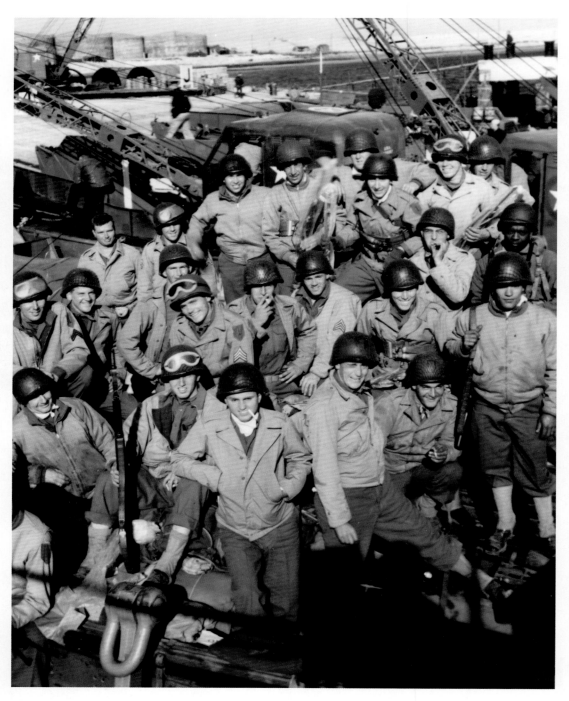

These American troops have loaded their equipment onto an LCT and are waiting for the signal that will dispatch them into 'the jaws of hell'. Almost 7,000 vessels took part in Operation Overlord, landing around 156,000 troops of which 73,000 were American. Some 23,000 airborne troops also took part. It is estimated that just under 4,400 Allied troops were killed on D-Day itself. A further 50,000 are thought to have died in the Battle of Normandy.

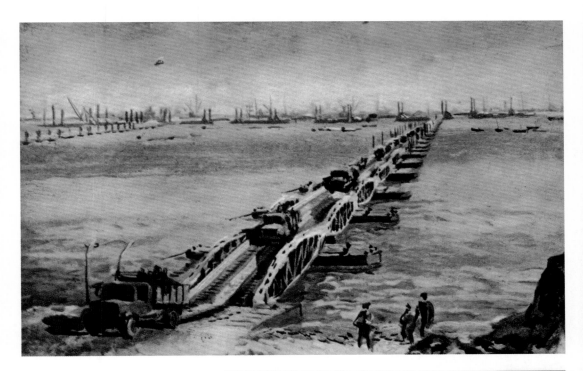

Above: The Mulberry 'B' port at Arromanches as recorded by the war artist Lieutenant Stephen Bone, the son of First World War artist Muirhead Bone, in the summer of 1944. Supplies are seen being brought ashore on the floating pierways.

Right: Two photographs of the devastation at Caen, which was captured by the Allies on 9 July. The area around Caen formed the most important road junction in Normandy and was fiercely defended by the Germans. The church of St Pierre has been reduced to a ruined shell in the heavy artillery and air bombardment.

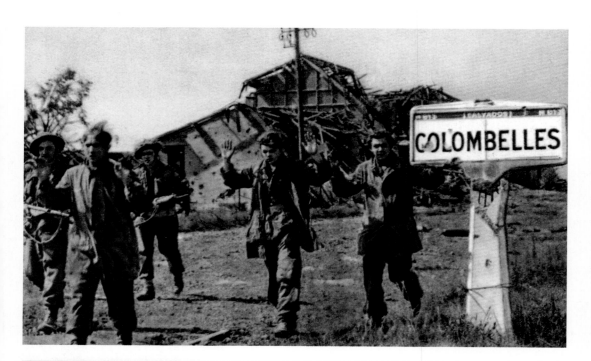

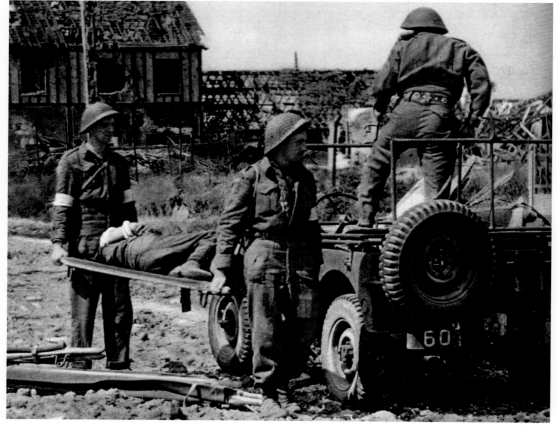

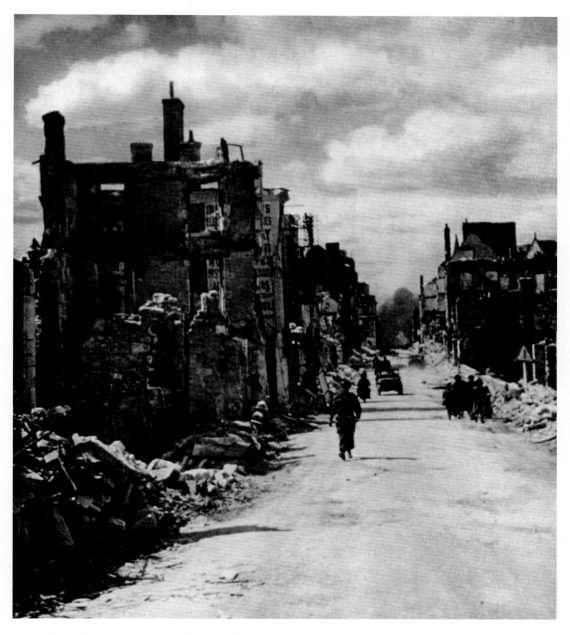

Above: The ancient town of Falaise, Calvados, was taken on 17 August 1944, during the final stages of the Battle of the Falaise Pocket or Gap – one of the bloodiest encounters on the Western Front in the Second World War and the decisive engagement of the Battle of Normandy. Hitler had ordered his Army Group B, with the 7th Army and 5th Panzer Division, to mount a counter-offensive, but in the event the German forces were encircled. They suffered heavy losses and the battle opened up a corridor to Paris and the German border for the Allies.

Opposite page: Scenes from the capture of Caen. *Top:* British and Canadian troops round up German prisoners. *Bottom:* Wounded being taken from the battlefield near Colombelles, an industrial district to the north-east of Caen.

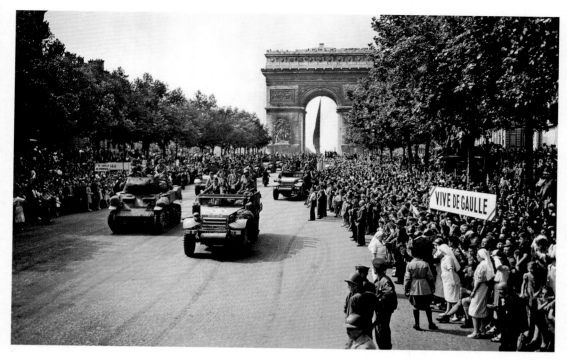

Above: Jubilant Parisians line the Champs-Élysées as Allied tanks and half-tracks roll down the avenue from the Arc de Triomphe on 26 August 1944, the day after the German garrison had surrendered the French capital. *Below:* Singing and dancing in the streets of Eindhoven in The Netherlands. The town was liberated by troops of the British 2nd Army on 18 September.

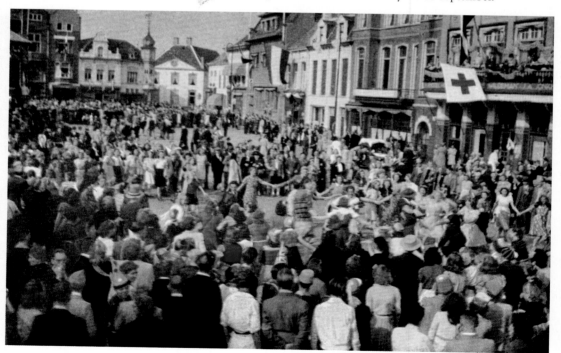

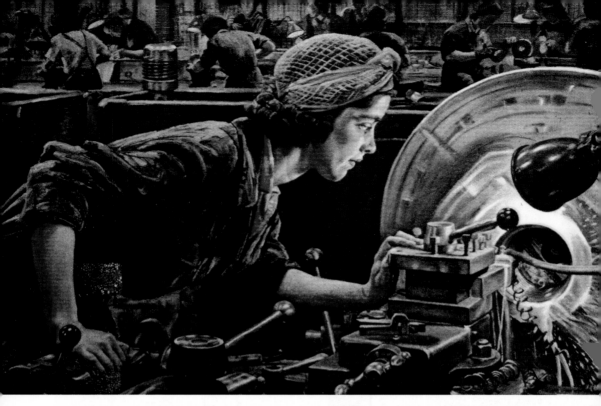

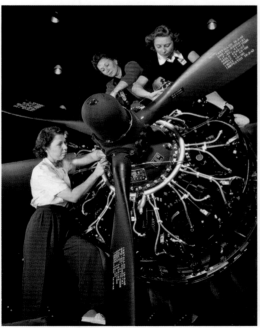

There was no let up in the demand for armaments and the women war workers on both sides of the Atlantic continued to play their part. *Top:* Dame Laura Knight's painting of Ruby Loftus screwing the breech ring of a Bofors gun in a Royal Ordnance factory. *Bottom:* Two photos of American women building Liberators at the Consolidated Aircraft plant at Fort Worth, Texas.

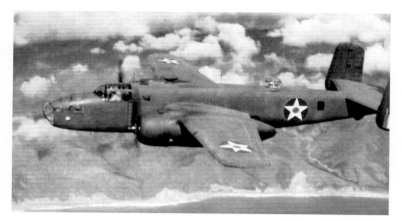

US Aircraft

Top left: The North American B-25 Mitchell medium bomber was powered by a pair of Wright double-row Cyclone radial engines. Service ceiling was 25,400 feet and it had a range of 2,650 miles. B-25s were used in 1942's Doolittle raid on Tokyo.

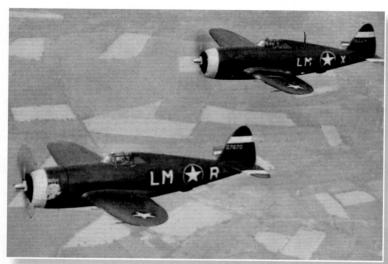

Middle left: The Republic P-47 Thuderbolt was one of the largest and heaviest fighter-bombers.

Below: A yellow Stearman training biplane in front of a row of Curtiss SB2C dive-bombers, known as Helldivers, which were used extensively in the Pacific.

Top right: By January 1944 all US combat aircraft were left unpainted, giving the aircraft of the later stages of the war a distinctive bare metal finish. Here a worker at North American Aviation is putting the final touches to a P-51 Mustang.

Bottom right:
A formation of four yellow-tailed P-51Ds of 52nd Fighter Group. The Mustang was a long-range single-seat fighter and fighter-bomber, which first flew in October 1940 and entered service in 1942. The P-51D saw several improvements and became the most numerous variant with nearly 8,000 built. It arrived in Europe in quantity in 1944 and became the USAAF's primary long-range escort fighter, and it appeared in the Pacific theatre by the end of 1944.

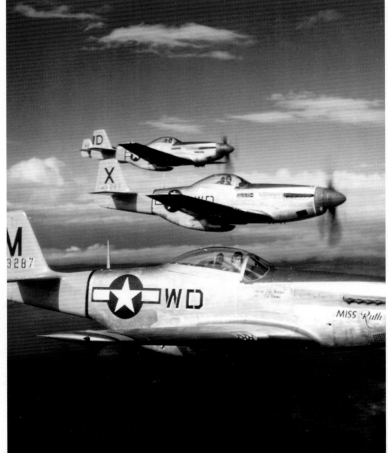

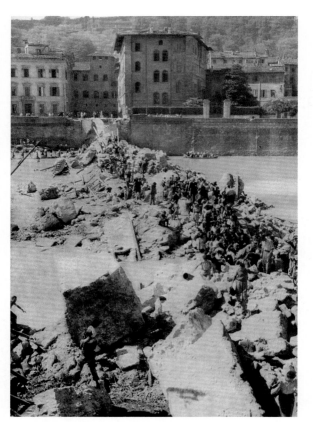

The Allied Advance in Italy

Left: The ruins of the Ponte alle Grazie, Florence, used to cross the Arno by Florentines returning to their homes after the Germans had evacuated the city on 11 August 1944. Fortunately the river is at its lowest summer ebb.

Below: A British soldier is sniping in the ruins of Cassino, the scene of fierce fighting during the Battle of Monte Cassino. The 5th and 8th armies had reached Cassino on 2 February 1944, but fierce resistance with artillery assaults launched by the Germans in high positions in the hills overlooking the town, most notably in the historic abbey, meant that it was not until 18 May that the defenders were driven out, finally opening the way for the Allied push towards Rome.

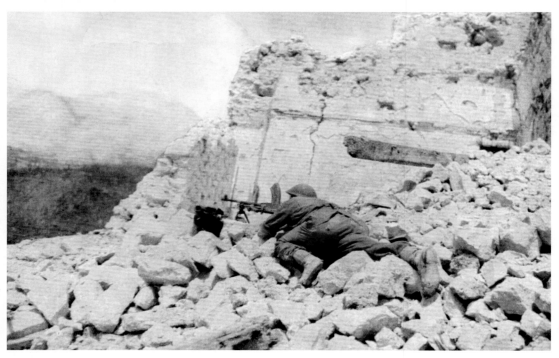

Above: A soldier of the Royal Signals is making repairs to a recently shelled pontoon bridge across the River Garigliano, January 1944.

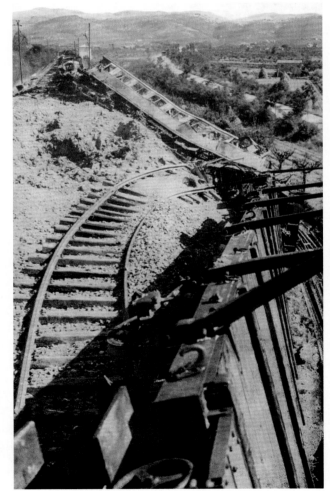

Right: Further damage inflicted on the transport infrastructure. This train and the railway track have been extensively damaged by an Allied bombing attack, July 1944.

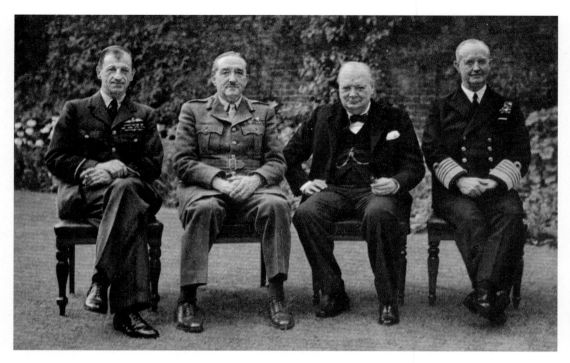

Above: The British prime minister, Winston Churchill, photographed in the gardens at Downing Street with his chiefs of staff. From the left; Air Chief Marshal Sir Charles Portal, General Sir Alan Brooke, (Churchill) and Admiral Sir Andrew Cunningham. *Below:* Churchill meets with President Roosevelt, surrounded by their various chiefs of staff, at Quebec, October 1944.

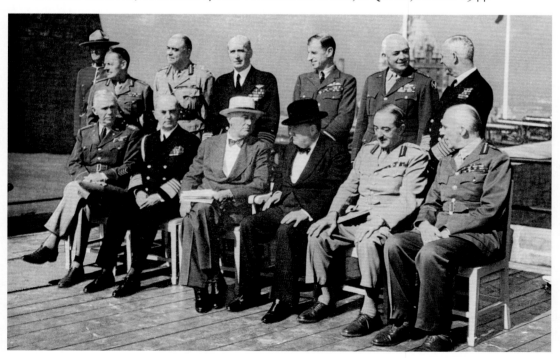

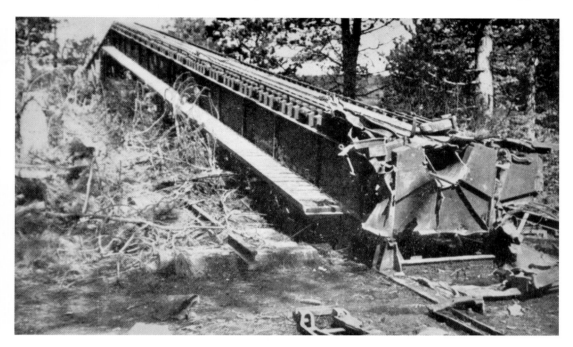

Shadow over England

Above: A V1 launch ramp at Belloy-sur-Somme. Once the launch sites in northern France had been overrun by the advancing Allied forces in October 1944, the missiles were launched from modified Heinkel He 111 bombers over the North Sea.

Below: The Allies obtained detailed information on the V1 flying bomb from examples which fell to earth intact near the launch sites.

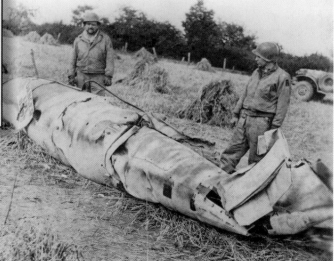

Tank Wars
The Second World War saw huge strides in tank design. Shown above, a German soldier sits on a French Char B1 Bis wrecked in the Battle of France, 1940, one of the most powerfully armed tanks of its day. *Below:* The ubiquitous M4 Medium tank, better known as the Sherman to the British. It was tough, reliable and produced in such prodigious quantities – with over 49,000 constructed – that it became a war winner. The M4 was built in several variants.

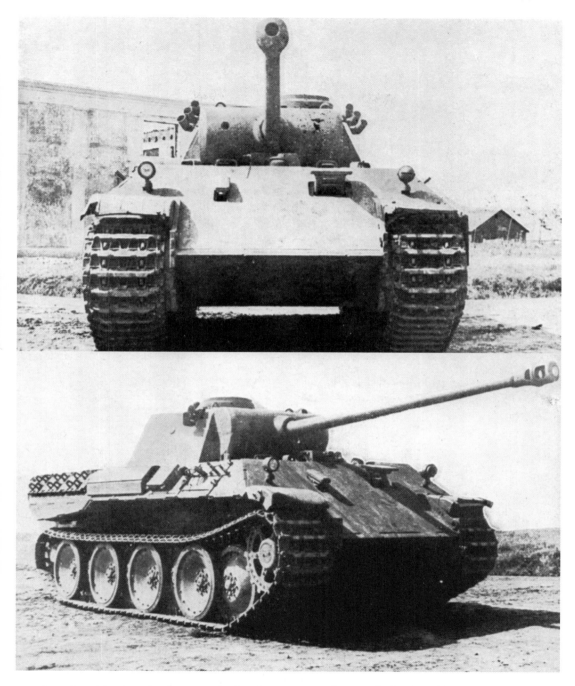

Introduced into service in 1943, the Panther was a medium tank developed by Germany as a counter to the Soviets' T-34, and a successor to the Panzer III and Panzer IV. Although there were only two Panther-equipped regiments in France at the time of the Allied landings in Normandy, by the end of June this had been boosted to nine regiments with a strength of up to 432 tanks. In total around 6,000 Panthers were built during the war.

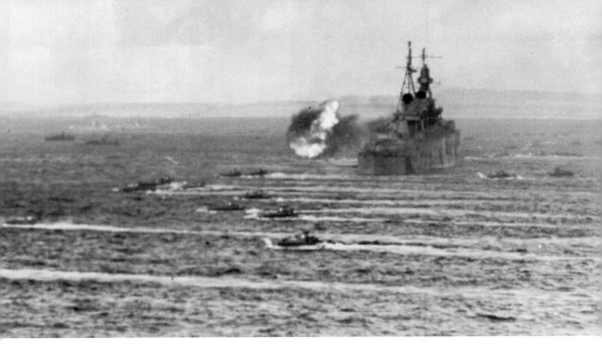

The Battle of Saipan

This took place in the Pacific theatre from 15 June to 9 July 1944 and saw the defeat of the 43rd Division of the Imperial Japanese Army. *Above:* USS *Indianapolis*, the flagship of the 5th Fleet commander Admiral Raymond A. Spuance, fires its guns as the fleet of landing craft heads towards the beach at Saipan in the Mariana Islands. *Below:* The first wave of US Marines hit the beach in the Marianas invasion. *(US Navy)*

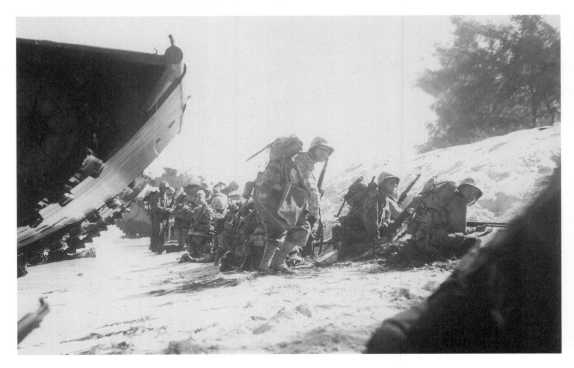

Above: US Marines firing a captured Japanese gun at Saipan during the attack on Garapan, the island's administrative centre. *Below:* Beneath the guns of USS *South Dakota* a service is held to honour shipmates killed in action at Guam, 19 June 1944.

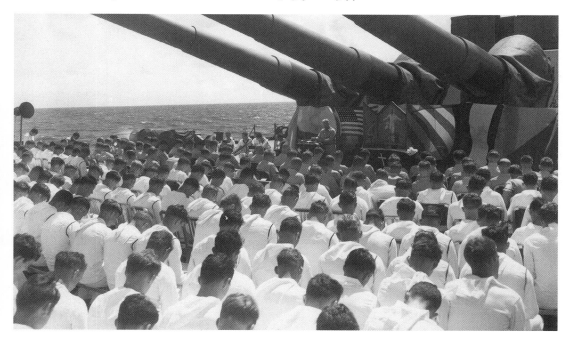

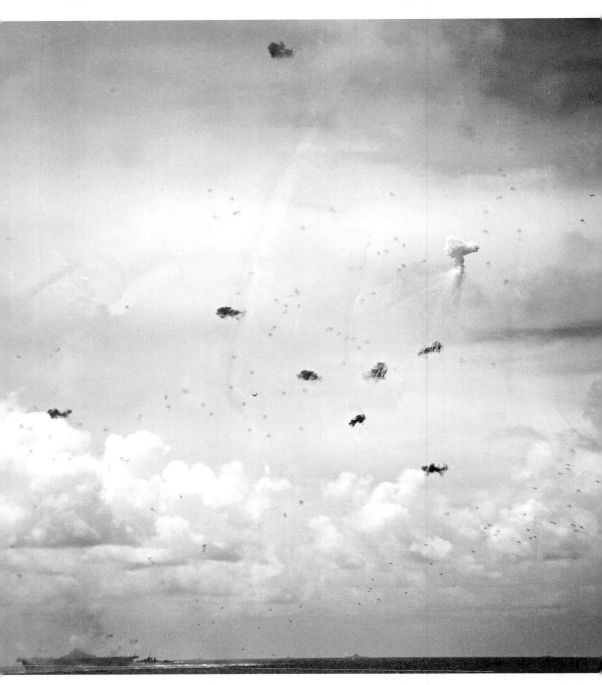

The Battle of the Philippine Sea
This action took place on 19–20 June, during the amphibious US invasion of the Mariana
Islands. *Above:* The sky is peppered with anti-aircraft flak as Japanese aircraft attack the
American carrier USS *Wasp*.

Above: A US Navy Grumman TBF Avenger of Torpedo Squadron VT-8 is poised to launch from the deck of USS *Bunker Hill* for a strike against Saipan. The Avenger was a three-man torpedo bomber. *Below:* US Marine Corps Vought F4U-1A Corsairs near Eniwetok. *(US Navy)*

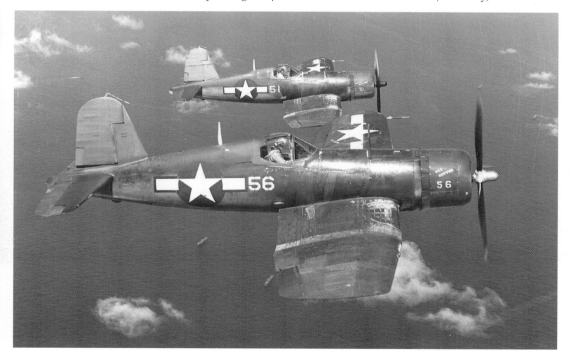

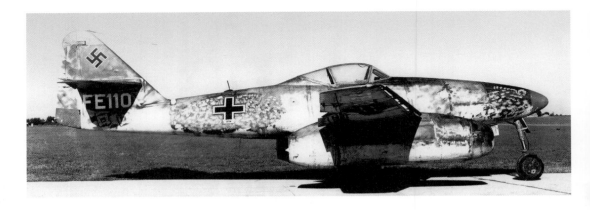

German Jets Enter Service

In 1944 the Luftwaffe had the distinction of introducing two jet aircraft into service. The first was the revolutionary Messerschmitt Me 262-1A, shown above, a sleek fighter-bomber powered by two Jumo Ju 004 turbojets. Erprobungskommando 262, or Ekdo 262, was formed in April 1944 as a test unit based at Lager-Lechfeld in Bavaria, and one of their aircraft is credited with damaging an RAF Mosquito reconnaissance aircraft on 26 July. The second jet to enter service was the Arado Ar 234, shown below, otherwise known as the Blitz or Blitz-Bomber. This twin-engined jet had first flown in June 1943 and was also powered by a pair of Jumo 004 engines. It became operational in September 1944, and although intended as a fast bomber it was mainly used in the reconnaissance role.

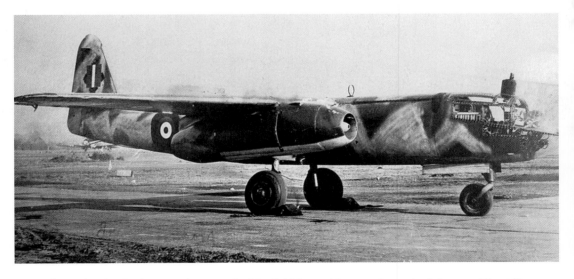

Above: An Arado Ar 234 photographed in British markings at the end of the war. The Allies took a keen interest in Germany's work with jets and many examples were taken as the spoils of war by the British, Americans and the Soviets.

JULY 1944

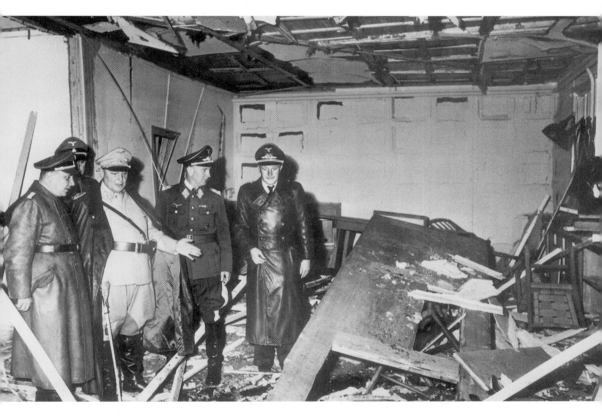

The 20 July Plot to Kill Hitler

Above: Adolf Hitler narrowly escaped death when a bomb detonated in his Wolf's Lair field headquarters near Rastenburg, East Prussia. It had been taken into the meeting by Claus von Stauffenberg, but the briefcase containing the bomb was moved by one of Hitler's officers who pushed it to the far side of supports for the heavy oak conference table. Four died in the blast, but not the Führer, whose trousers were singed, and it is likely that he suffered a perforated ear drum. Four of the ringleaders, including von Stauffenberg, were executed by firing squad in Berlin that night. As a result of the investigations into the assassination attempt and planned *coup d'état* that was to follow, more than 7,000 people were arrested and 4,980 of them executed. As for Adolf Hitler, he took his survival to be a 'divine moment in history'.

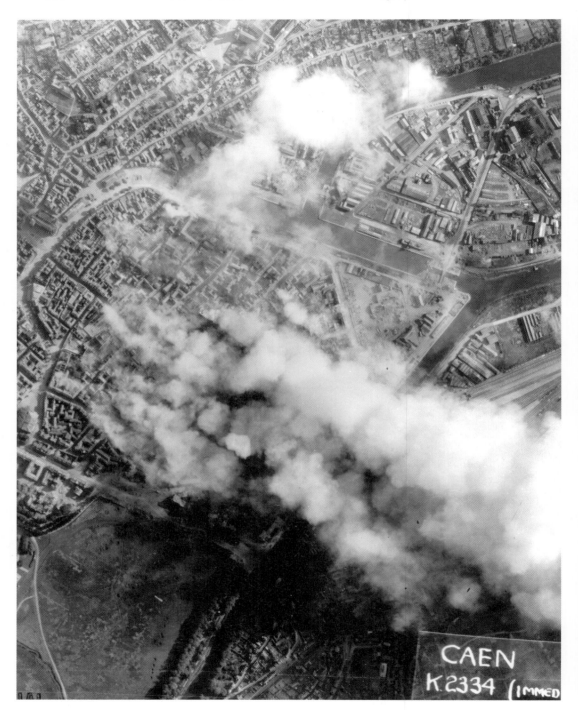

The Caen Offensive
Above: The bombing of Caen saw much of the old Norman city destroyed. The battle to take Caen had dragged on from 6 June, right through July, and did not end until 6 August.

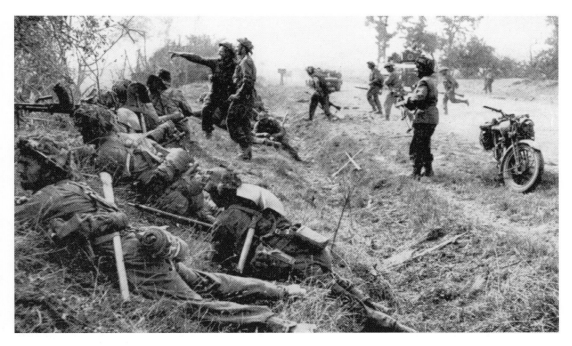

Above: Making a limited breakthrough south-east of Caen, the Allied forces take possession of the village of Cagny. *Below:* Heavy rains interfered with the Allied operations and brought a lull in the Caen offensive. Jeeps negotiate a flooded street in the Bretteville area.

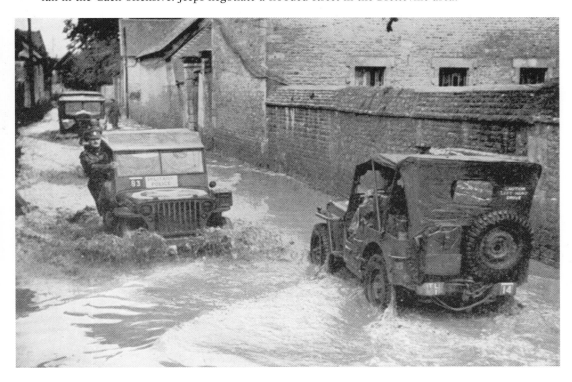

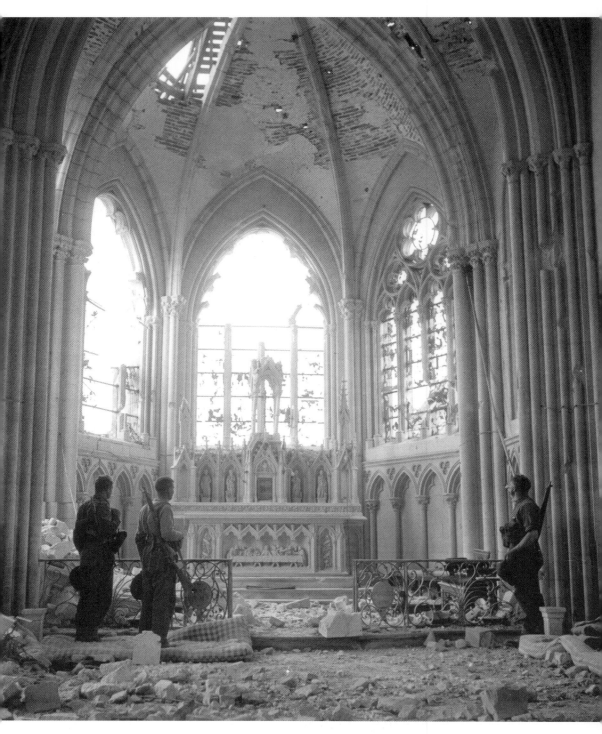

Above: Soldiers of the 9th Canadian Infantry Brigade pause in a shattered church in Carpiquet, to the west of Caen, on 12 July 1944. *(NARA)*

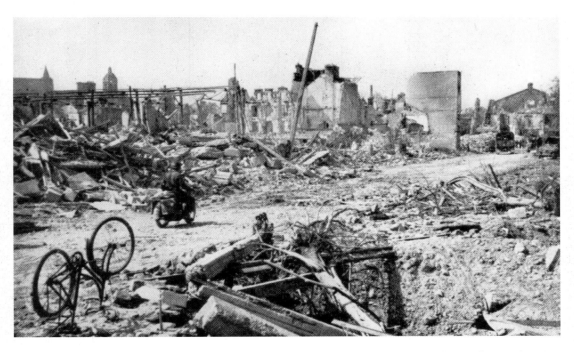

Above: The Allied attack in the Caen area on 18 July led to the occupation of Vaucelles on the following day. This photograph shows the extent of the damage in one part of the town. *Below:* Bread delivery by Jeep. Two British soldiers emerge from their 'hole-in-the-wall' observation post to receive their ration of bread for the day.

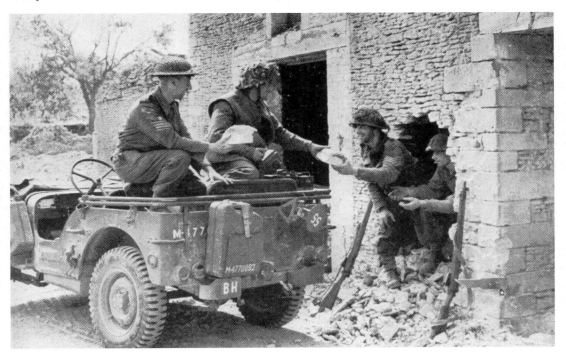

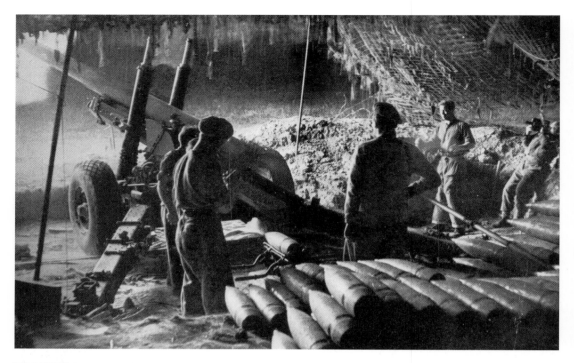

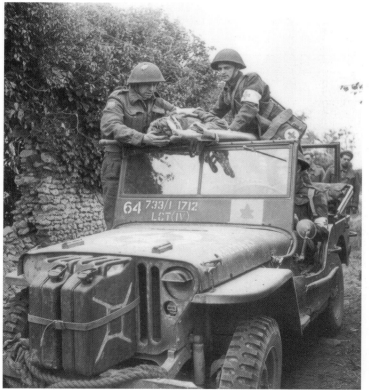

Above: A British gun pit
near Evrécy. This is one
of the 5.5-inch guns that
supported the night attack
made by the 2nd Army on
15 July.

Left: Canadian medics
evacuate the wounded on
a Ford-built Jeep. During
the war around 637,000
Jeeps were built by both
Willys-Overland and the
Ford Motor Company.

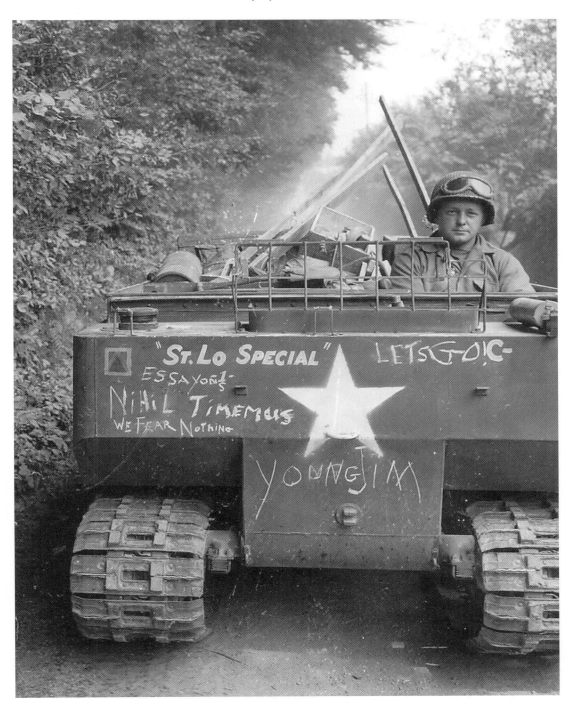

Above: The 'St Lo Special.' This small, tracked vehicle is a M-29 Weasel, photographed here near St-Lô. Built by Studebaker, it was designed for use in snow, but also saw service in the Normandy breakout because of its ability to reach areas where wheeled vehicles couldn't go.

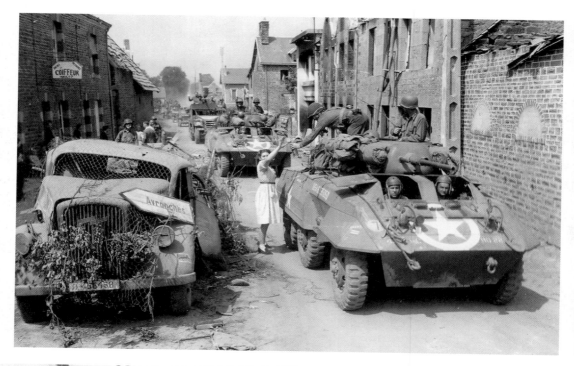

Above: Vehicles of the 4th Army in Le Repas, Folligny, on 31 July 1944. Folligny is located in the south-west corner of the Normandy peninsula. The six-wheeled vehicles are M-8 Light Armoured cars known as Greyhounds and built by Ford. The M-8 was used by British and American troops.

Left: A diver of the Royal Navy being lowered from Cherbourg's causeway to a small boat from which he will be submerged to take part in the salvage operation in the harbour.

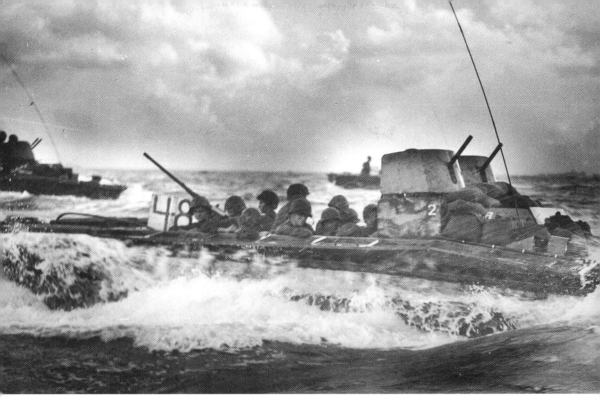

The Pacific Campaign in the Northern Mariana Islands
Above: An amphibious Buffalo, loaded with US Marines, makes it way through choppy waters to the beaches of Tinian Island near Guam. *Below:* Coming ashore on to the island, 24 July.

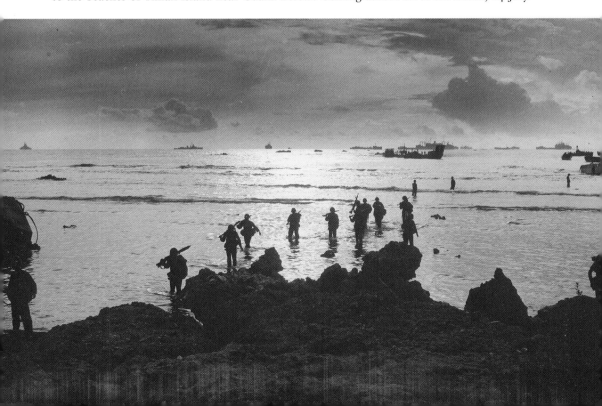

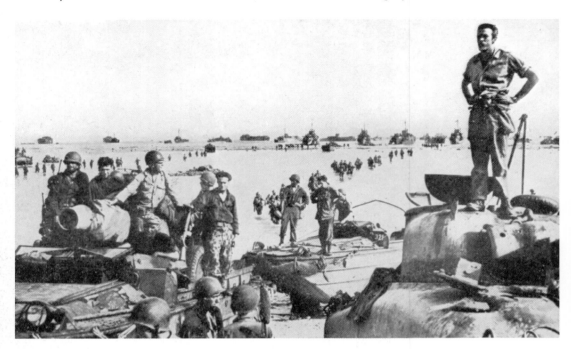

Above: US troops coming ashore from landing craft lying off Noemfoor, or Numfor, Island in the Papua Province of Indonesia. The Battle of Noemfoor took place between 2 July and 31 August. *Below:* Heavy losses were incurred by the American forces when the Japanese launched a counter-attack on Saipan Island.

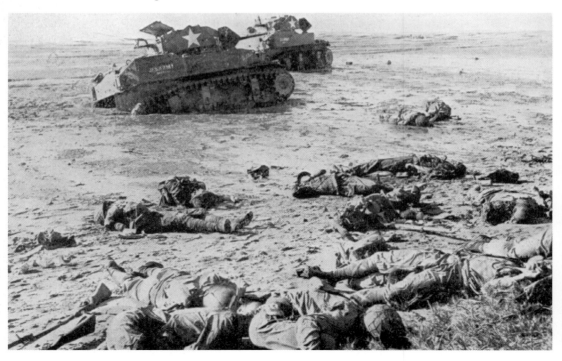

Right: Night firing of US 155-mm artillery guns on Guam, 29 July.

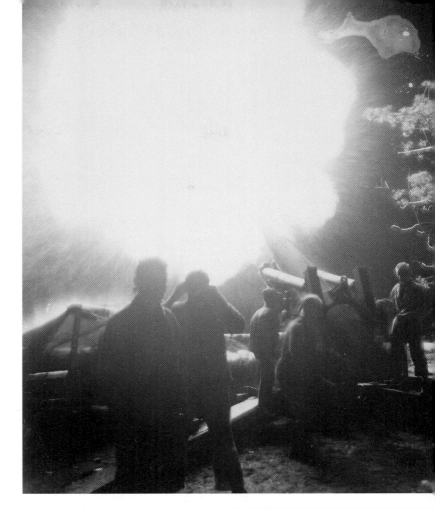

Below: US Marines move past a wrecked Japanese dive-bomber on the way to Agat beach, Guam.

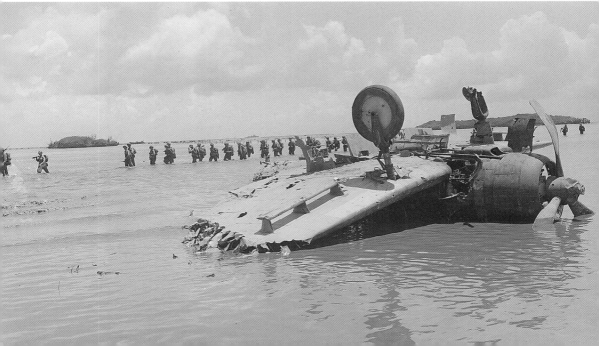

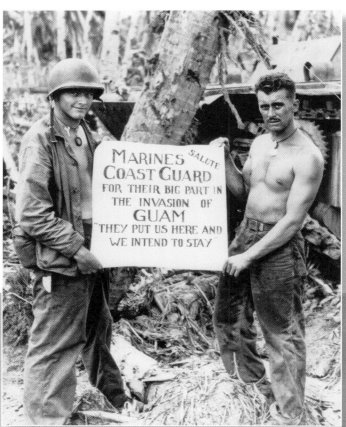

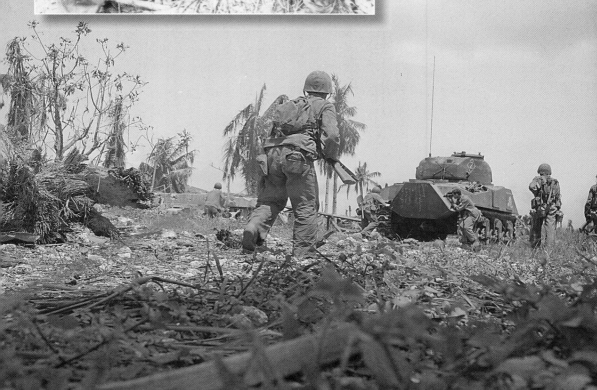

Left: US Marines on Guam salute the Coast Guard for their part in the invasion, July 1944. *(US DoD)*

Below: The Marines advance behind a Sherman tank on Guam.

AUGUST 1944

The Mediterranean Campaign
The British Special Boat Service and specially trained forces known as the Greek Sacred Band, shown above, made a surprise landing on the German-occupied Aegean island of Symi. The raid, also known as Operation Tenement, took place from 13 to 15 July 1944. Although they were forced to withdraw, it achieved its objective with many German vessels and facilities destroyed. It also forced the Germans to post a larger garrison on Symi, thus tying up their resources in the area.

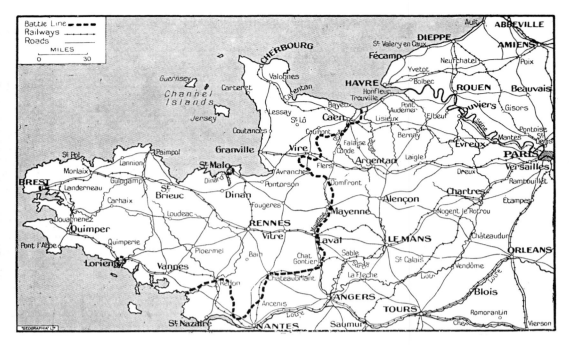

Above: A map showing the Allied advance in Normandy and Brittany by 8 August. The offensive, begun on 25 July, saw the greater part of Brittany cleared of the enemy. *Below:* Ike inspects an overturned German tank at Chambois, part of the Falaise Pocket. *(NARA)*

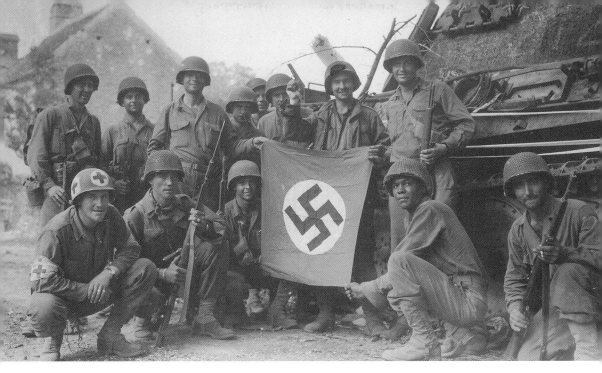

Above: US troops display their latest trophy, a Nazi flag acquired during the 'mop-up' of Chambois in August 1944. *(NARA) Below left:* A young Japanese man in German uniform, one of the prisoners rounded up in the breakout from Normandy. *Below right:* Churchill had promised Stalin a second front to take the pressure off the Soviets.

"BUT WESTWARD, LOOK!
THE LAND IS BRIGHT."

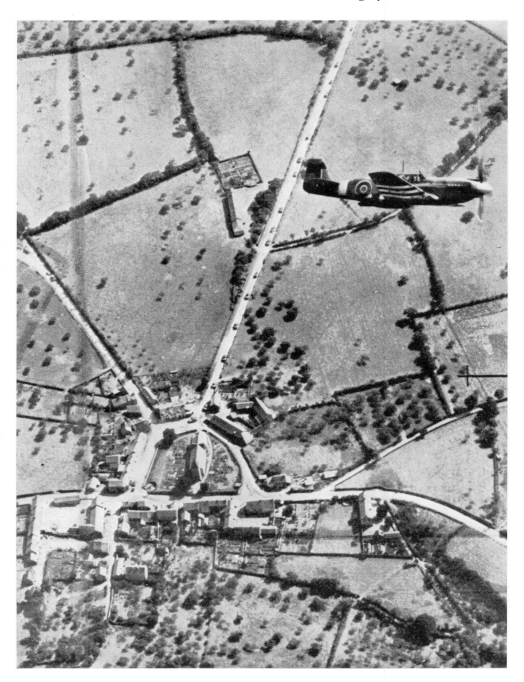

Above: Under the watchful eye of an RAF Mustang, an Allied tank convoy is approaching a little village in Normandy on the way to the front during the Battle of the Falaise Gap or Pocket, 12–21 August, to the south of Caen. The pocket around Falaise had been formed by the German Army Group B, with the 7th Army and the Fifth Panzer Army. The battle resulted in the destruction of most of Army Group B west of the Seine, thus opening the way to Paris.

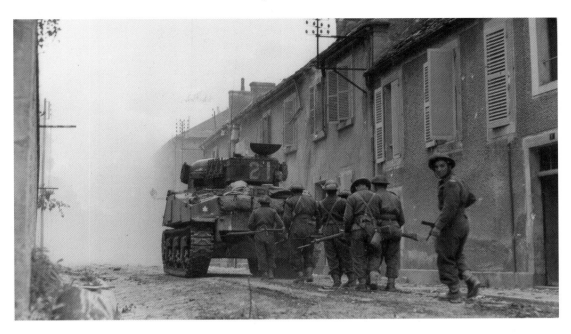

Above: Canadian troops move through Falaise under the cover of a Sherman tank. *Below:* still wearing their helmets, German forces are shown surrendering at St Lambert-sur-Dive, to the east of Falaise. *(Library & Archives Canada)*

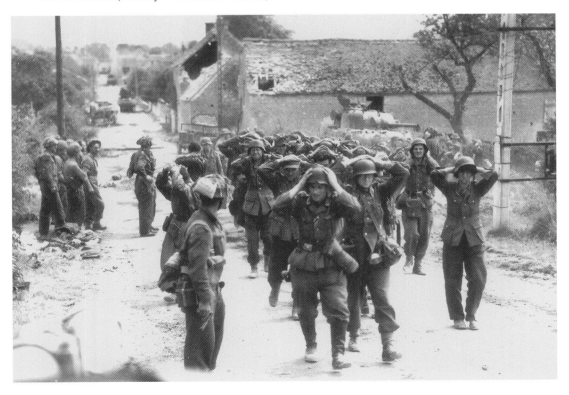

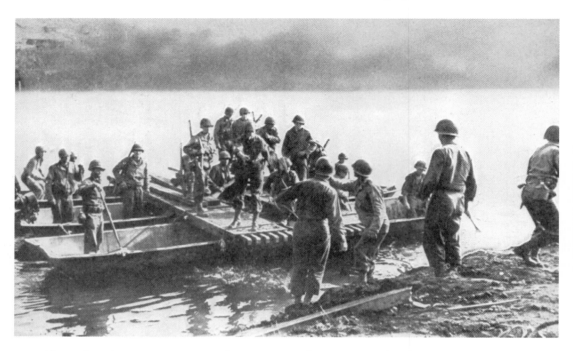

Above: American troops crossing the River Seine by a pontoon ferry built by the engineers.
Below: A lorry load of Red Cross nurses in service with the US Army on their way to the Seine
battle-front. They are passing through the town of La Loupe, 45 miles west of Paris.

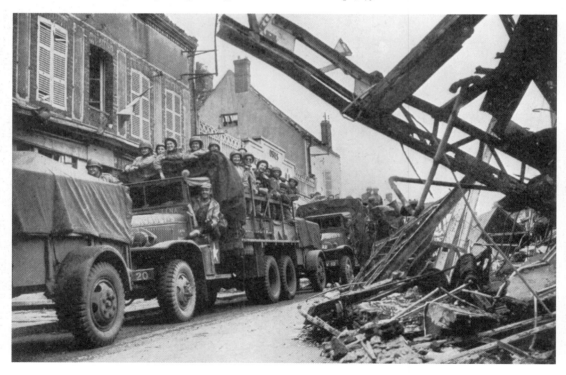

Paris is Liberated!
On the night of 24 August the French Resistance had staged an uprising against the German garrison, and elements of the 2nd French Armoured Division fought their way into the city. The following morning the bulk of the 2nd Armoured Division and the US 4th Infantry Division entered Paris.

Right: US troops look on as the Tricolor is raised on the Eiffel Tower.

Below: Men of the US 28th Infantry Division march down the Champs-Élysées during the Victory Parade held on 29 August.

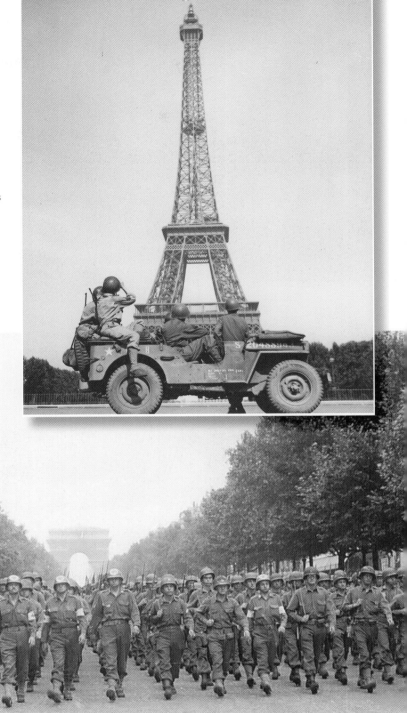

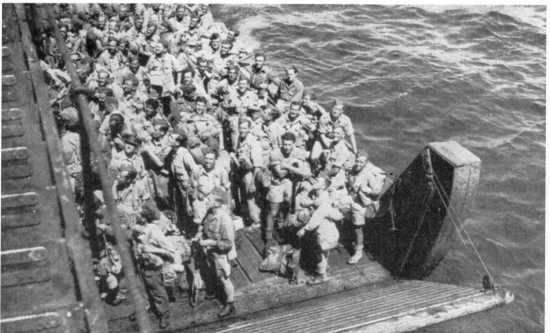

Operation Dragoon – Allied Landings in Southern France
Overshadowed by Operation Overlord, Dragoon saw the Allied invasion of southern France
on 15 August by both airborne and amphibious forces. *Top:* As the troops went ashore on
the Riviera coast, Winston Churchill watched the proceedings from HM destroyer *Kimberley*.
Bottom: RAF ground staff wait in a landing craft for transport to one of the landing beaches.

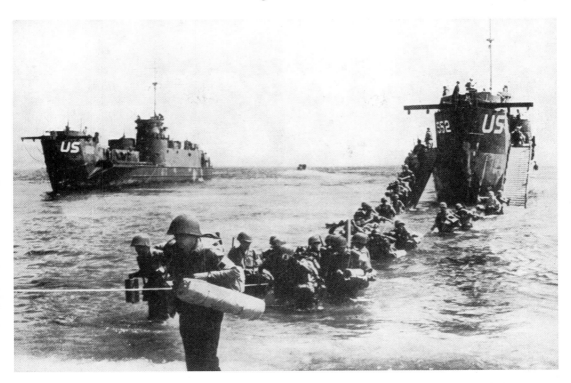

Above: US infantrymen wading through the water to come ashore at Toulon. *Below:* An American soldier takes aim with a bazooka, a recoilless rocket launcher.

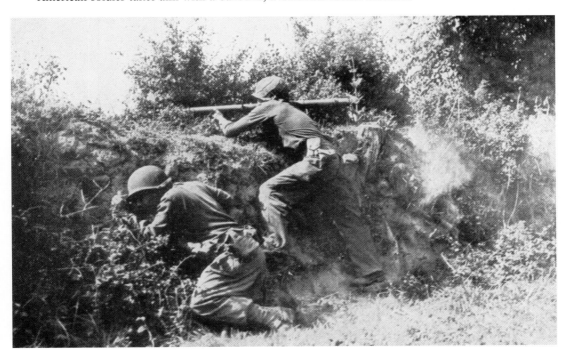

Above: Officers and ship's company of HMS *Tactician*, a British T class submarine, on their return from a nineteen-month spell in the Mediterranean and the Far East. In August 1944 she began a refit at Chatham Dockyard. *Below:* The view from a Swordfish aircraft departing from HMS *Chaser* while on anti-submarine patrol. She was built by the Americans as USS *Breton* and transferred to the UK under the Lend Lease agreement.

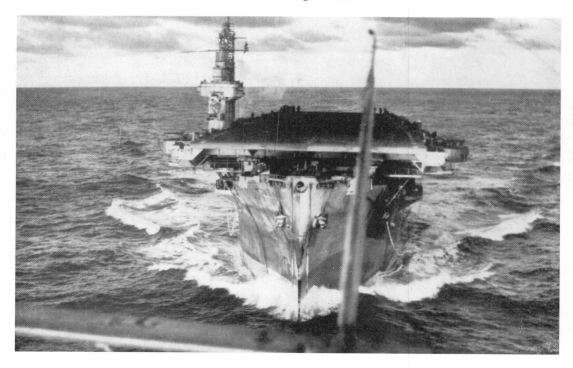

SEPTEMBER 1944

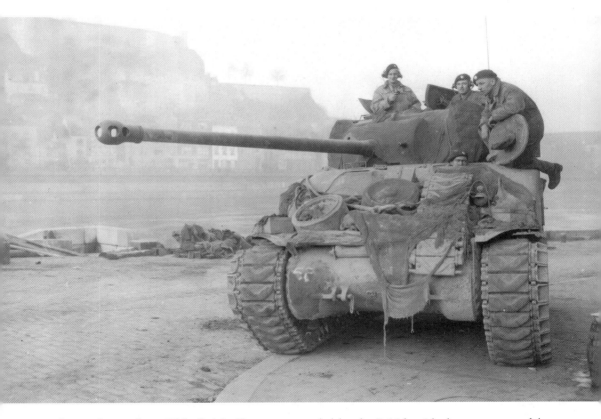

Above: The Firefly, a US-built M4 Sherman upgraded by the British with the more powerful 17-pounder anti-tank gun. It is shown patrolling the Meuse at Namur. In September 1944 the 3rd Army had halted at the Meuse for several days during the Battle of Nancy. *(US Army)*

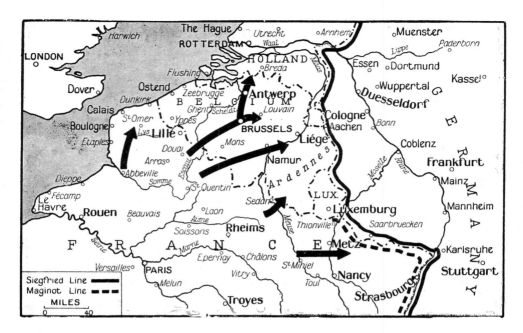

Above: This map shows the general direction of the Allied advance through Belgium. Brussels was liberated on 3 September, and the Allies swept forward to Antwerp near the Netherlands border. *Below:* These women are collaborators, shown amid a group of German prisoners taken when Le Havre was captured on 12 September. The city had been heavily bombed by the RAF.

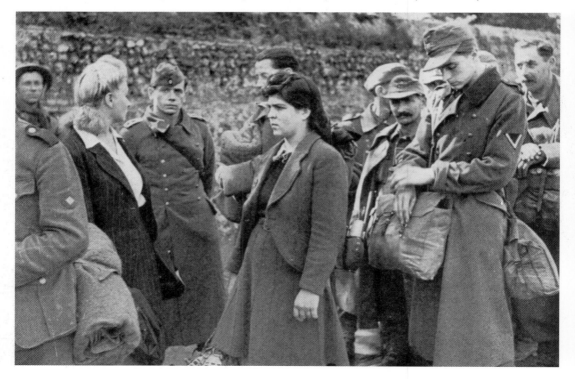

Above: A nurse of the Belgian White Army bandages the arm of a British soldier wounded in the fighting at Antwerp. The city had been liberated by the British 2nd Army on 4 September with help from local resistance fighters. *Below:* In the six months after liberation Antwerp was targeted by the German V weapons, mostly V2 rockets. See page 140.

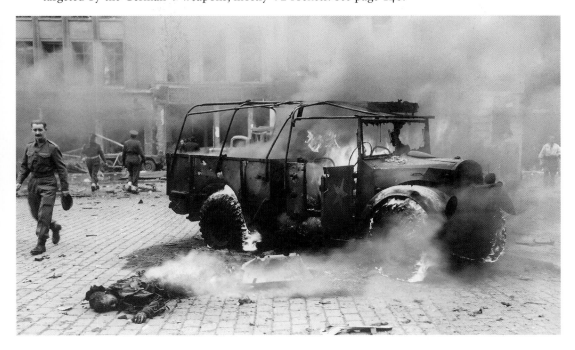

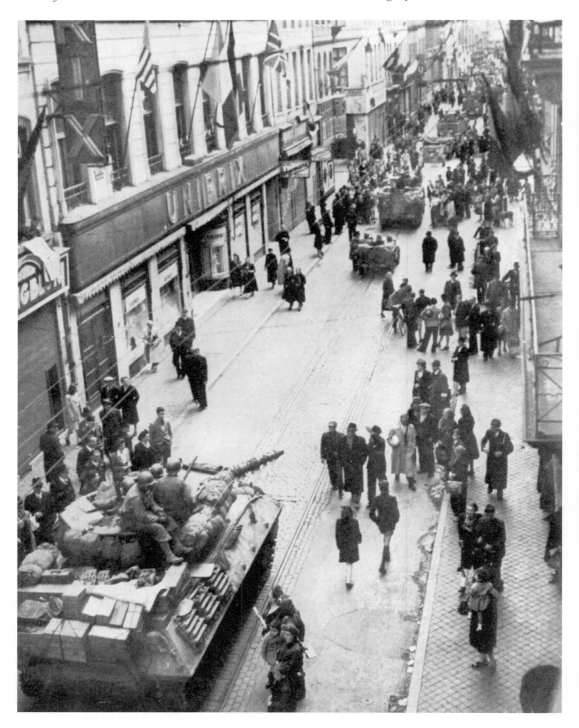

Above: Soldiers of the US 1st Army passing through one of the main streets of Liège on 8 September receive a warm welcome from the townspeople.

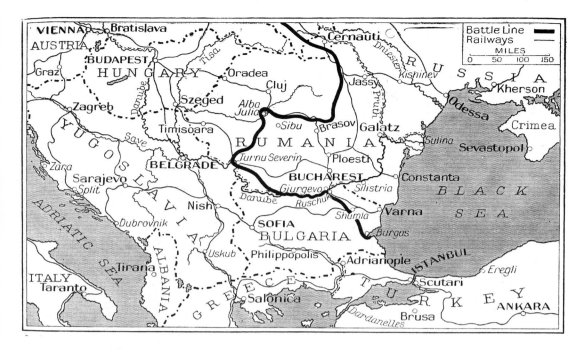

Fighting in the Balkans and Hungary

Above: Position of the Red Army who, with their Rumanian allies, were fighting the Germans in Rumania. *Below:* Hungarian machine-gunners firing on the Soviet forces.

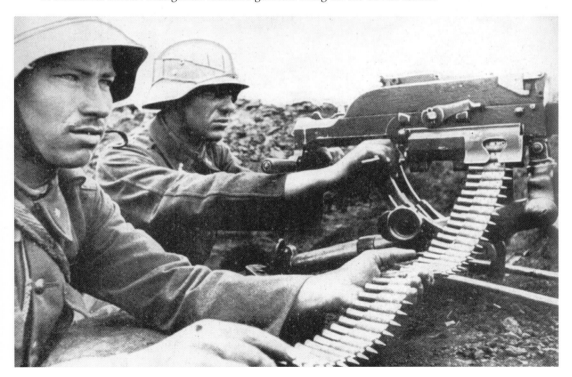

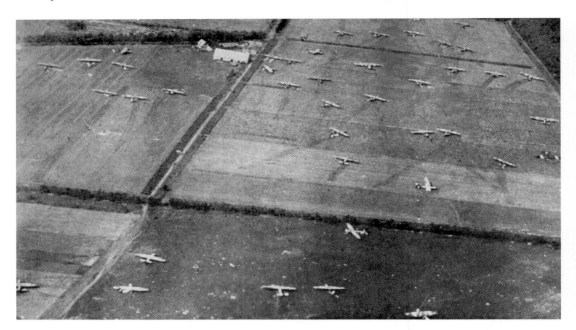

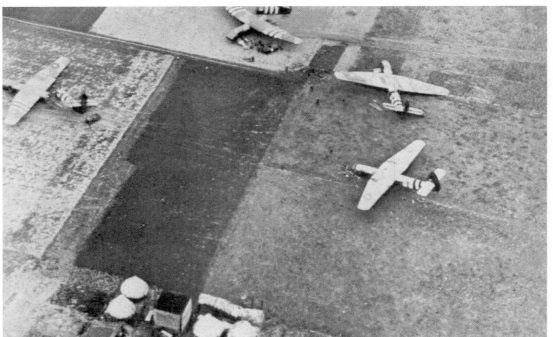

Operation Market Garden
On 17 September the Allies carried out airborne landings in Eindhoven, Nijmegen and Arnhem in the Netherlands to seize the bridges over strategic river and canal crossings. *Above:* Two images ahowing the swarm of gliders on the ground. *Opposite page:* Ahead of the gliders there was a mass descent of paratroopers of the 1st Allied Airborne Army. *(US DoD)*

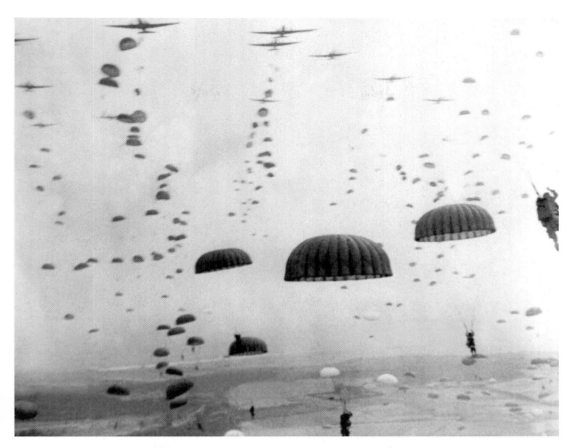

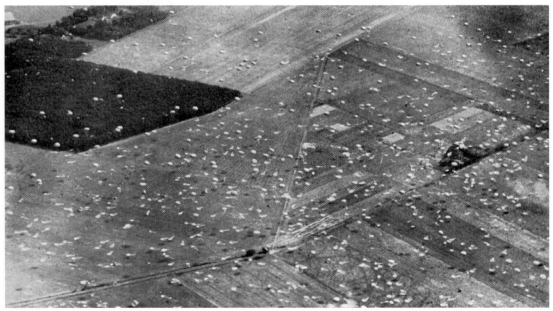

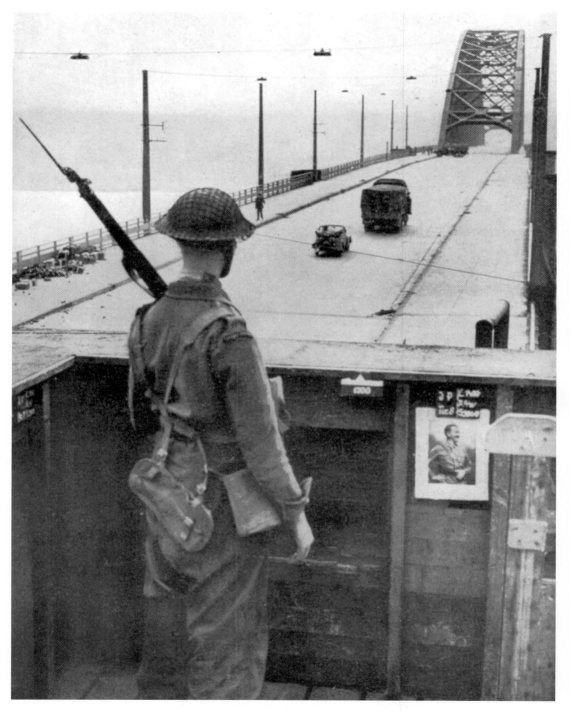

Above: A soldier of the 2nd British Army guards the bridge across the Rhine at Nijmegen, which was captured by American paratroopers on 20 September.

Above: The two bridges at Nijmegen. On the left, and shown opposite, is the road bridge. The other carries the railway which passes north through Elst to Arnhem. *Below:* British engineers dismantle the 10,000 lbs of explosives placed in the bridge piers by the Germans.

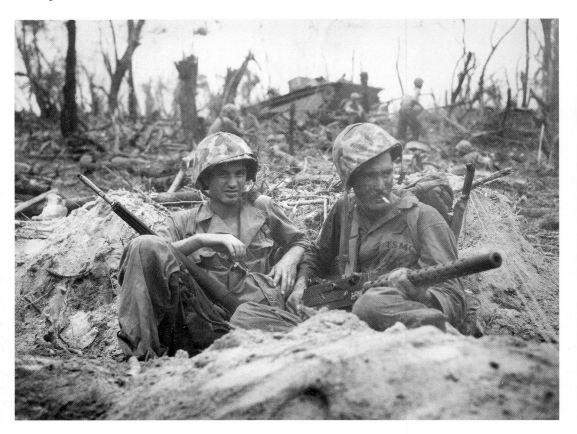

The Battle of Peleliu

Codenamed Operation Stalemate II, the battle to capture the airfield ran from 15 September until 27 November 1944 on the island of Peleliu, present-day Palau.

Above: US Marines of the 1st Marine Division on Peleliu Island. They were later joined by men of the 81st Infantry Division. Together they suffered almost 10,000 casualties during their time on the island.

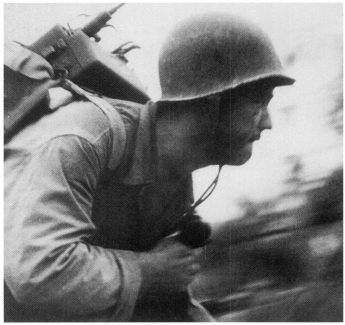

Left: A Marine charges across the beach at Peleliu with a walkie-talkie on his back.

Right: US Marines installing telephone lines while under fire on Peleliu. In the background is Bloody Nose Ridge, the scene of the fiercest fighting.

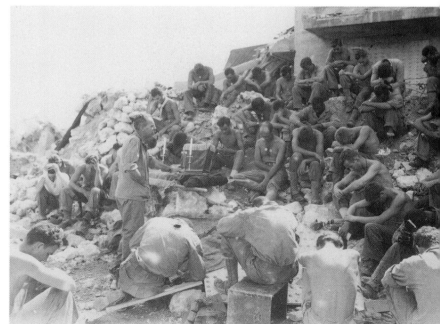

Bottom right: A chaplain holds a service within a few hundred yards of the Japanese postions in September 1944. *(NARA)*

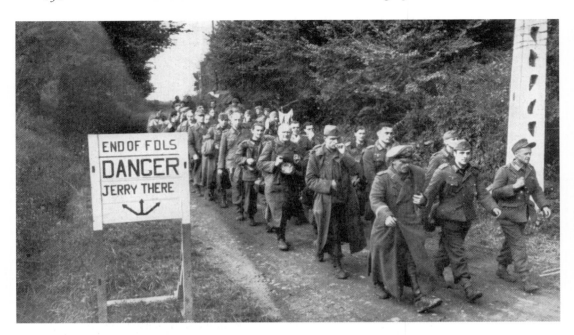

In August Hitler had declared the port of Boulogne to be a fortress, but in the event it surrenderd to the Allies on 22 September. Shown above, some of the German prisoners being marched towards the Canadian lines. *Below:* One of the big 14-inch calibre guns, located between Cap Gris Nez and Wimereux, used by the Germans to bombard Dover.

Above: A German Mk IV tank concealed in a damaged house. *Below:* Before the final assault on Calais an armistice of twenty-four hours was arranged for the safe evacuation of civilians. The liberation of the fortified port by the 3rd Canadian Infantry Division came six hours after the resumption of fighting on 30 September.

The V2 rockets

As an artillery weapon, the V2 was developed by the German army entirely separately from the flying V1. Its original designation was A4, the fourth in a series of Aggregat rockets. This is the German term for a mechanical system and the designation V2, for Vegeltungswaffe or 'retribution weapon', was the creation of Goebbels' Reich Ministry for Propaganda. The V2 rocket stood almost 46 feet tall. At the tip was the warhead, next came the automatic gyroscopic control system, then the fuel tanks – which accounted for the bulk of the missile's weight and volume – the upper one holding an ethanol/water mixture and the lower tank liquid oxygen, and at the base there was the rocket motor, exhausts and four control fins.

An assembly line had been established at Peenemünde by the summer of 1943, but following the Operation Hydra air raids by RAF bombers, on the night of 17/18 August 1943, production was dispersed underground, most notably to the Mittelwerk factory under the Harz mountains in central Germany. The first V2 attack against London was on 8 September 1944 when a rocket came down in Chiswick, killing two people. At first the government blamed the explosions on defective gas mains, then on 10 November Churchill informed Parliament the England had been under rocket attack. On the receiving end the V2s were undetectable and unstoppable. They fell to earth at 2,200 mph and there were no warnings, no air raid sirens, and for those on the ground it was as if the explosion was instantaneous. By the end of the V2 attacks, 2,754 civilians had been killed in London and another 6,523 injured.

Below: A British cutaway diagram of the V2 rocket.

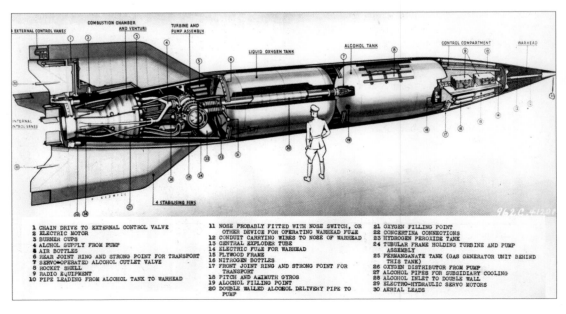

1 CHAIN DRIVE TO EXTERNAL CONTROL VALVE	11 NOSE PROBABLY FITTED WITH NOSE SWITCH, OR OTHER DEVICE FOR OPERATING WARHEAD FUZE	21 OXYGEN FILLING POINT
2 ELECTRIC MOTOR	12 CONDUIT CARRYING WIRES TO NOSE OF WARHEAD	22 CONCERTINA CONNECTIONS
3 BURNER CUPS	13 CENTRAL EXPLODER TUBE	23 HYDROGEN PEROXIDE TANK
4 ALCOHL SUPPLY FROM PUMP	14 ELECTRIC FUZE FOR WARHEAD	24 TUBULAR FRAME HOLDING TURBINE AND PUMP ASSEMBLY
5 AIR BOTTLES	15 PLYWOOD FRAME	25 PERMANGANATE TANK (GAS GENERATOR UNIT BEHIND THIS TANK)
6 REAR JOINT RING AND STRONG POINT FOR TRANSPORT	16 NITROGEN BOTTLES	26 OXYGEN DISTRIBUTOR FROM PUMP
7 SERVO-OPERATED ALCOHOL OUTLET VALVE	17 FRONT JOINT RING AND STRONG POINT FOR TRANSPORT	27 ALCOHOL PIPES FOR SUBSIDIARY COOLING
8 ROCKET SHELL	18 PITCH AND AZIMUTH GYROS	28 ALCOHOL INLET TO DOUBLE WALL
9 RADIO EQUIPMENT	19 ALCOHOL FILLING POINT	29 ELECTRO-HYDRAULIC SERVO MOTORS
10 PIPE LEADING FROM ALCOHOL TANK TO WARHEAD	20 DOUBLE WALLED ALCOHOL DELIVERY PIPE TO PUMP	30 AERIAL LEADS

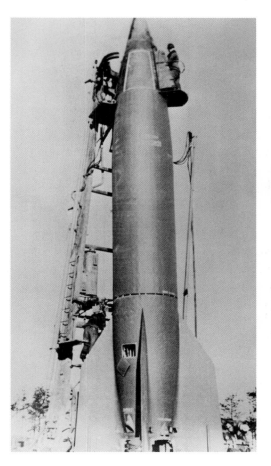

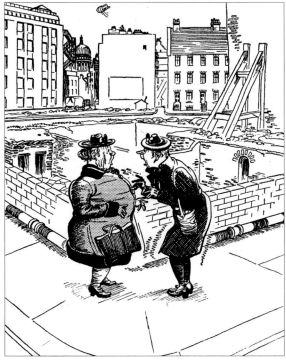

Above: Technicians tend to a V2 rocket which has been raised into the vertical position prior to launching.

Top right: The designer behind the rockets was Wernher von Braun, shown here in the centre wearing a civilian suit during a visit by General Dornberger to Peenemünde in October 1944.

Bottom right: 'OHH! ...and I hear they're going to loose on us a terrible secret weapon that we'll neither see nor hear nor smell, and which won't have the slightest effect on us whatsoever!' Admirable wartime humour is displayed in this newspaper cartoon.

Top left: A row of V2 fin sections lined up in a tunnel at the Mittelwerk factory under the Harz mountains. Production of the V2 had been dispersed and moved underground following the devastating raids on Peenemünde in August 1943.

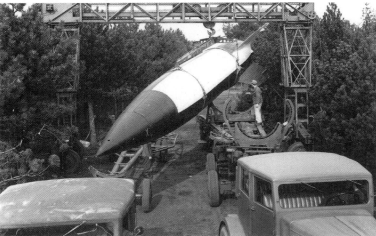

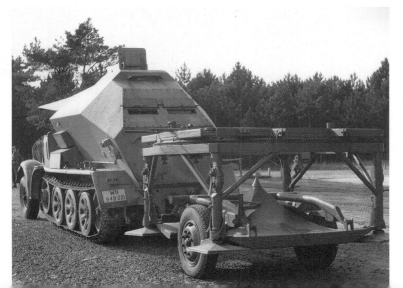

Middle and bottom left: Mobile launches avoided attracting the attention of Allied aircraft. The unfuelled rocket is shown being hoisted from its transporter on to a Meillerwagen which would act as the service and launch gantry. The armoured launch control vehicle has towed the launch platform to the site and will be moved further back as the rocket is fuelled and launched.

OCTOBER 1944

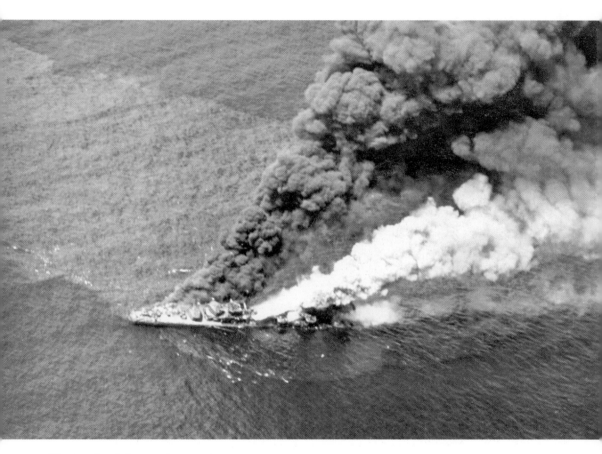

The Battle of Ormoc Bay
Above: A Japanese destroyer burns off Leyte in the Philippine Islands after being attacked by US carrier-borne aircraft on 11 November 1944. It was a bad day for the Imperial Japanese Navy with the sinking of the destroyers *Naganami* and *Hamanami*, *Shimakaze* and *Wakatsuki*.

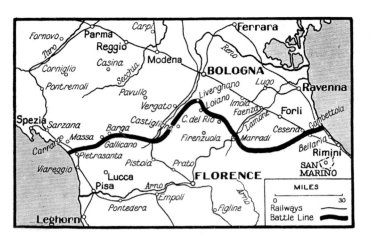

Left: Map showing the coast-to-coast battle-line on the Italian front at 17 October 1944.

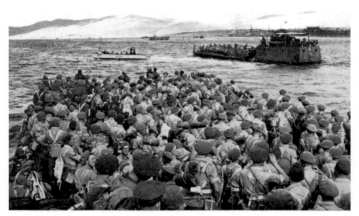

Progress in Greece

Middle left: Landing craft packed with British soldiers on their way to Piraeus, where they went ashore on 16 October following the capture of Athens by airborne troops.

Below: An RAF aerial photograph showing the landing at Piraeus, the port of Athens. The harbour is full of landing craft and the troops swarm on to the harbour like tiny ants.

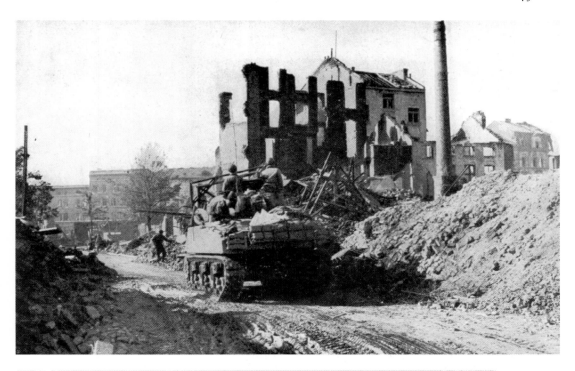

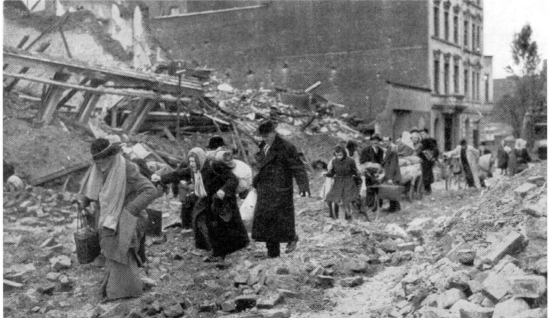

Into the Reich
On 21 October 1944, Aachen became the first big German town or city to fall to the Allies. *Top:* An American tank makes its way through the devastated streets of Aachen. *Bottom:* Aachen's civilians, who have been living in shelters and cellars for weeks, flee from the city.

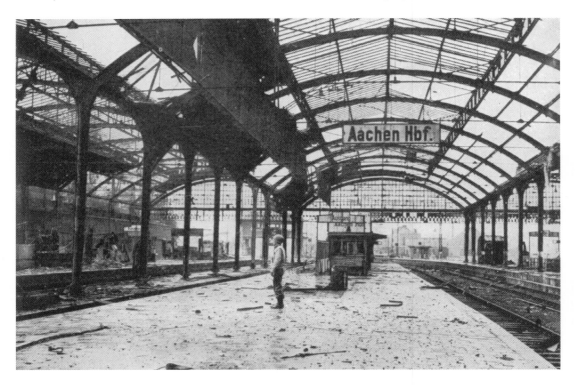

Above: Surveying the damage at Aachen's railway station. Not far away the main structure of the cathedral had survived intact, but both buildings had lost their glass. *Below:* A column of German prisoners streaming out of the city. Most were captured during the final stages of the fighting.

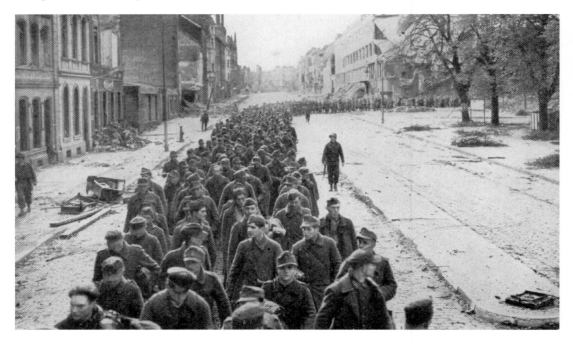

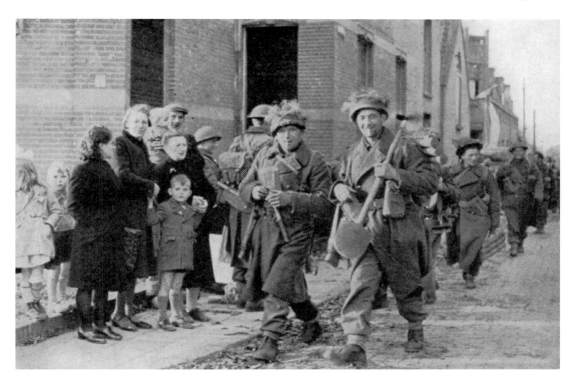

Above: The Dutch town of Breda was occupied by Polish troops of the Canadian 1st Army on 29 October. The civilians look on with satisfaction. *Below:* British troops use an amphibious Buffalo LVT (Landing Vehicle Tracked) to bring prisoners across the River Scheldt.

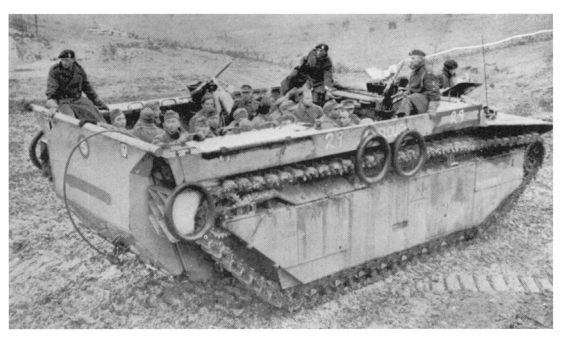

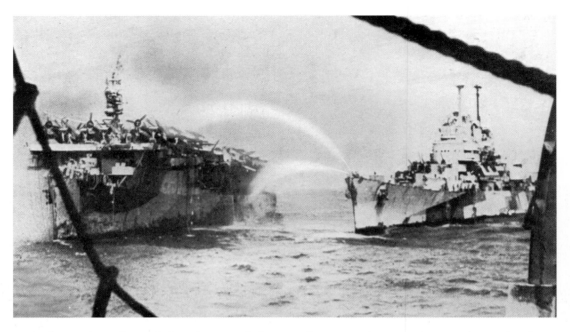

Above: The sinking of the US Navy's light aircraft carrier USS *Princetown* at the Battle of Leyte Gulf on 24 October 1944 after being attacked by a lone Japanese dive-bomber. USS *Birmingham* is pouring water on the stricken ship in an attempt to douse the fire. *Below:* US troops of the 6th Army landed on Leyte Island on 20 October

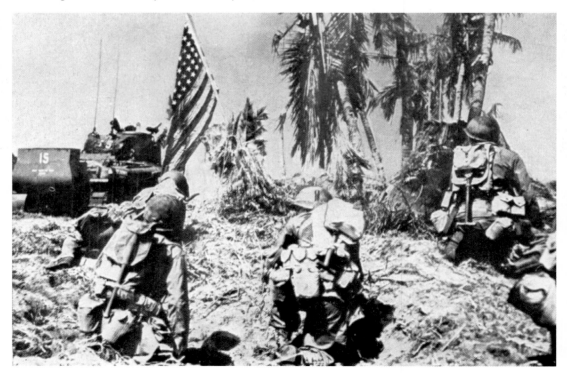

NOVEMBER 1944

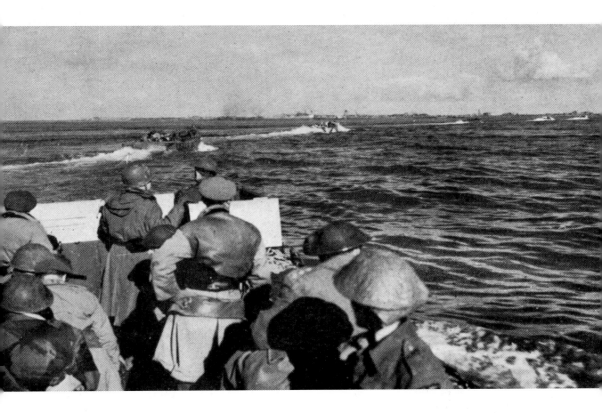

Above: British assault craft taking commando troops and infantry to Walcheren Island, located in the Scheldt estuary, at dawn on 1 November. They landed at Flushing and Westkapelle on the Dutch island.

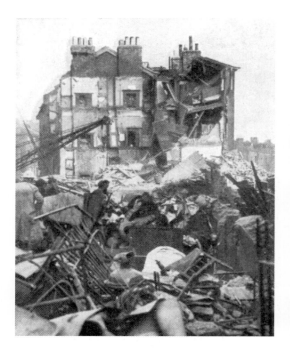

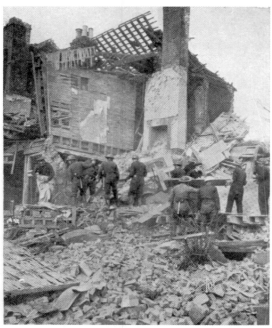

Unlike the V1 flying bombs, the ballistic V2 rockets arrived without warning. On 10 November Winston Churchill made a statement to Parliament confirming the existence of the V2s, confirming that the rockets reached a height of 50–60 miles. Travelling at speeds greater than sound, they were unstoppable and did extensive damage, as shown in these pictures of the crater and wreckage caused by a V2 strike.

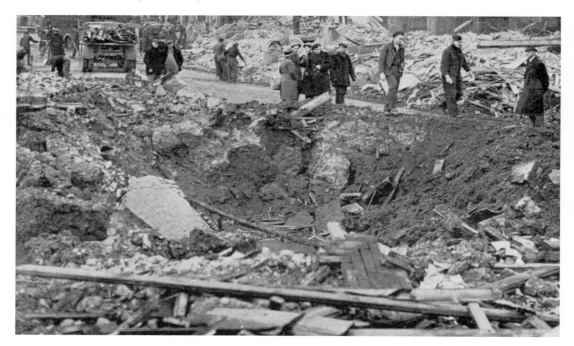

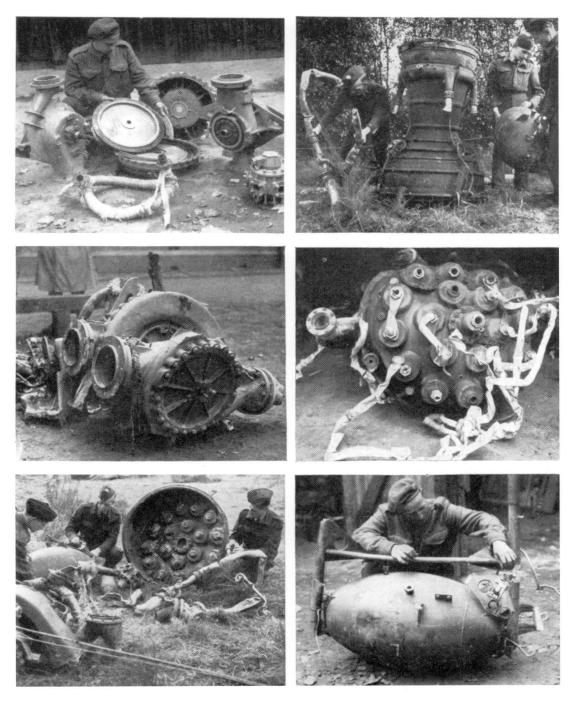

Above: Much of the information on the design and construction of the V2s came from parts found in the wreckage of rockets which had come down in Belgium. These photographs show various components including turbo-pumps for the liquid fuel, rocket nozzles, fuel jets and a hydrogen peroxide tank.

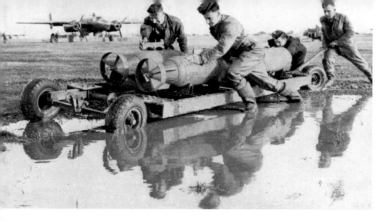

Top left: This airfield in Holland has been turned into a lake by heavy rain. Armourers wearing gum boots are pushing a trolley loaded with bombs for a B-25 Mitchell medium bomber.

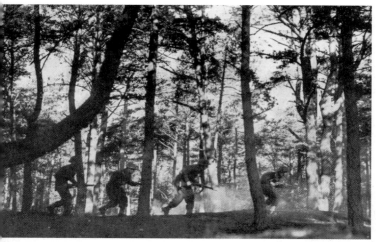

Middle left: Troops of the 2nd Army make their way through a heavily wooded area of Holland.

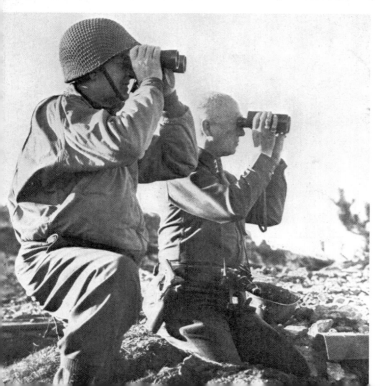

Bottom left: General Patton, with one of his staff officers, observes the fighting in the Nancy-Metz area where infantry and armour of the US 3rd Army launched an attack on 8 October 1944.

DECEMBER 1944

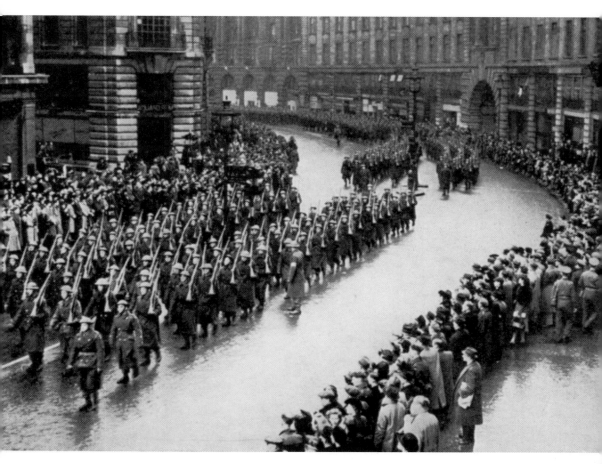

On 3 December contingents of the Home Guard took part in the stand down parade in central London. Shown above, 7,000 men march through Regent Street on the 3-mile circular route from Hyde Park. The king, accompanied by the queen and princesses Elizabeth and Margaret, took the salute at Stanhope Gate.

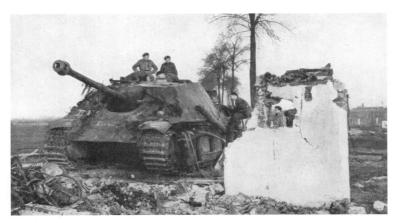

Left: Polish soldiers look over a 'super tank destroyer' knocked out at Langeweg. This is a German Jagdpanther, a 'hunter panther', introduced into service in 1944. Its design combined the powerful 8.8 cm PaK 43 cannon of the Tiger II with the armour and chassis of the Panther. Only 415 were built.

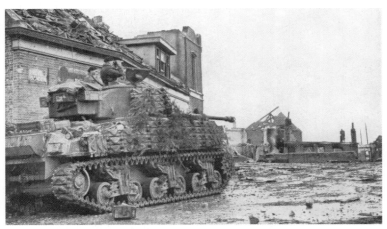

Middle left: A Sherman in Moerdijk, on the estury of the River Maas. Note the track links mounted to provide extra protection to its vulnerable flanks.

Below: A British Churchill, equipped with a Petard Mortar, rolls into Gilenkirchen, which was the scene of Operation Clipper in November 1944.

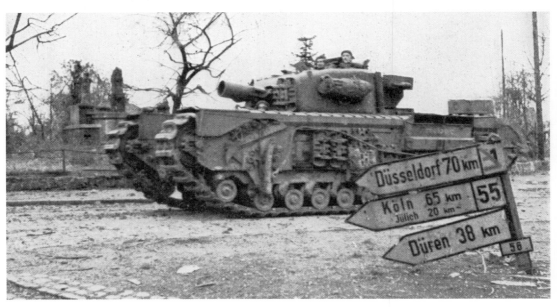

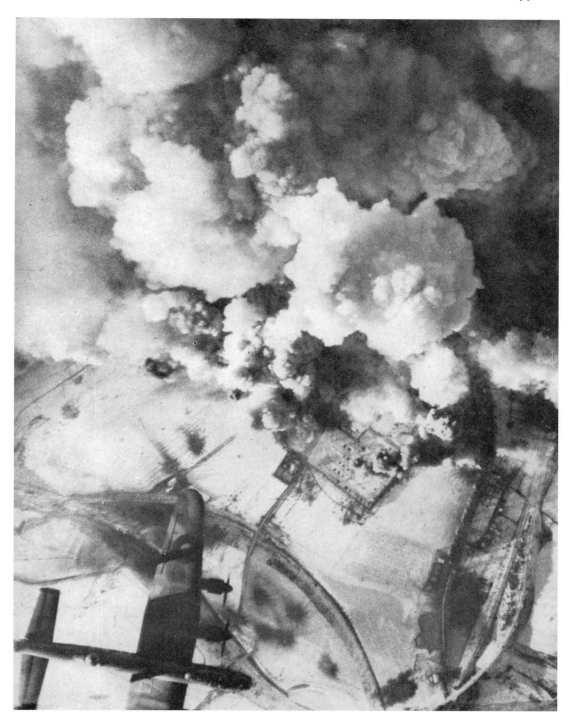

Above: On 26 December RAF Lancasters and Halifaxes attacked concentrations of enemy armour and supplies at St Vith, close to the German border in the Belgian province of Liège.

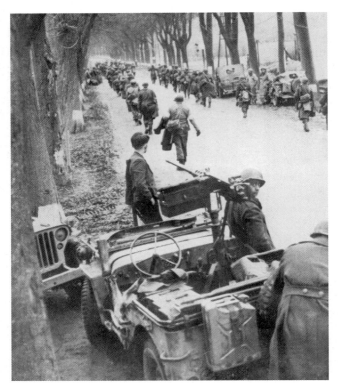

The Battle of the Bulge

Launching a surprise counter-attack on 16 December, the German Field Marshal von Rundstedt pushed deeply into the lightly defended Ardennes region of Belgium and Luxembourg. The intention was to push the Allies back in order to recapture the important port of Antwerp. The initial attack involved 200,000 men and 340 tanks. Generally known as the Ardennes Offensive, the German codename was Unternehen Wacht am Rhein, or Operation Watch on the Rhine.

Left: US troops moving up to the outskirts of a Belgian town to halt von Rundstedt's breakthrough

Below: Chow is served to US troops of the 347th Infantry Division on their way to La Roche, Belgium. *(NARA)*

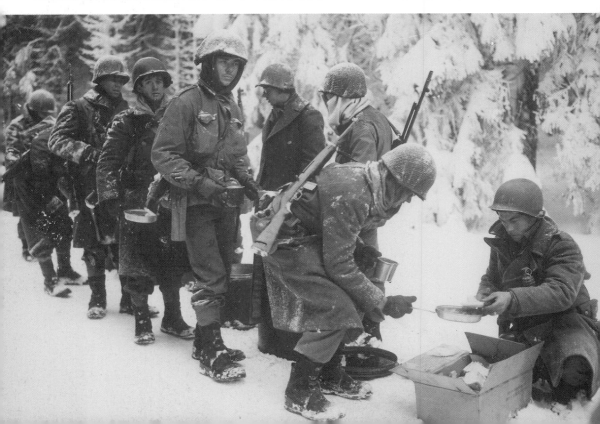

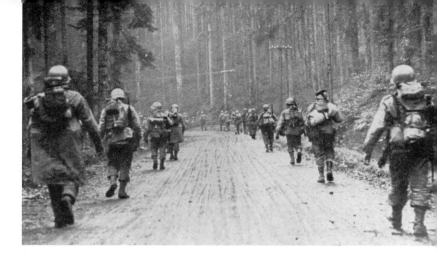

Right: Men of the 7th Army passing through a woodland region of the Vosges, an area in which the US forces cooperated with the French 1st Army. The Americans were to take the brunt of the German offensive and the Battle of the Bulge proved to be their largest and bloodiest battle of the war. It involved 610,000 men, of whom 89,000 were casualties, including 19,000 dead.

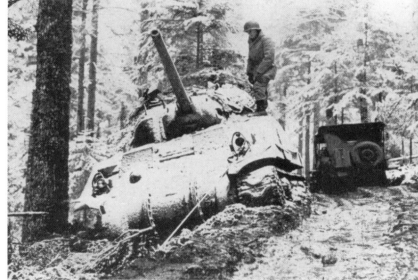

Middle right: A Sherman tank put out of action after striking a mine. It has been hauled to the side of the road to allow other vehicles to pass.

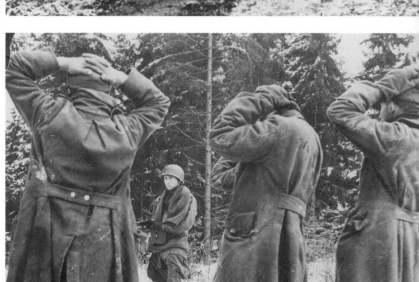

Bottom right: 50,000 German prisoners were taken in December alone. *(NARA)*

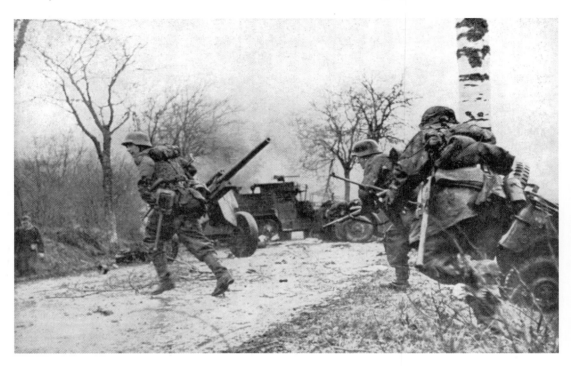

Above: German troops in the spearhead or bulge of the Ardennes offensive in December 1944. *Below:* US infantrymen of the 290th Regiment take cover amid the snow near Amonies, Belgium. *(US DoD)*

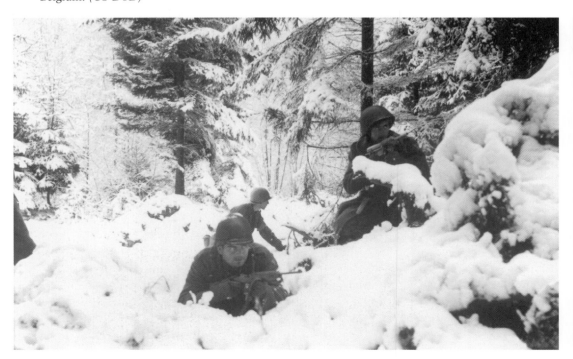

Fighting in Athens

By the end of 1944 Greece was descending into what became a fully blown civil war between the government forces and the military branch of the Greek communists. On 3 December, a bloody battle erupted after government police, with British forces in the background, opened fire on a pro-EAM (National Liberation Front) rally, killing twenty-eight of the demonstrators. The battle lasted for thirty-three days.

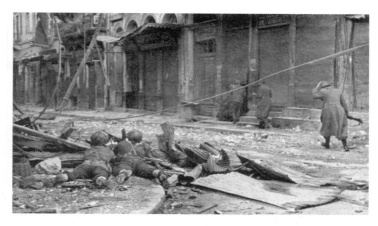

Top right: British paratroopers, accompanied by the Greek police force, move through a street, wary of snipers operating in the buildings.

Middle right: The troops take cover behind a tank.

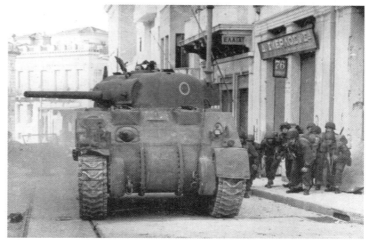

Below: Soldiers searching for hidden mines among the wreckage of a house.

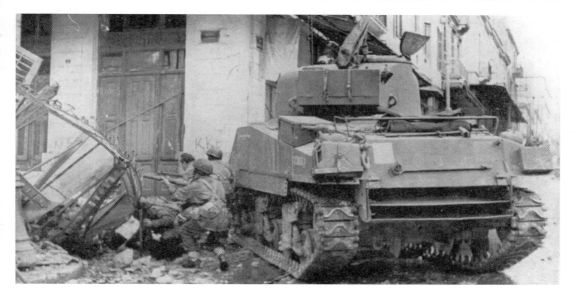

Above: Christmas dinner, 1944 style: eaten from a billy can in a slit trench near the forward position.

Left: 'Why walk the tightrope between life and death in 1945, become a prisoner of war.' A German propaganda leaflet intended to demoralise the Allied troops when they contemplate the year to come.